The Realism Challenge

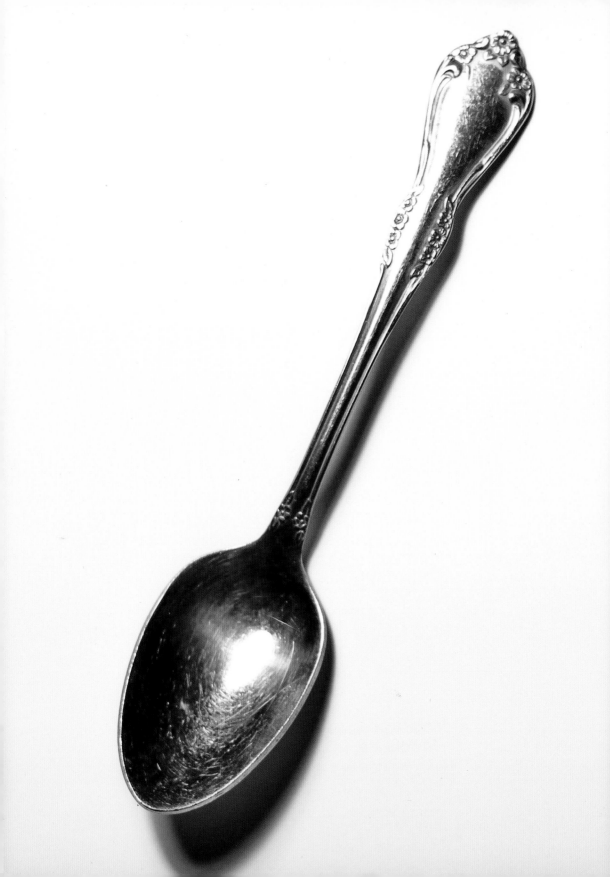

The Realism Challenge

Drawing and Painting Secrets
from a Modern Master of
Hyperrealism

MARK CRILLEY

WATSON-GUPTILL PUBLICATIONS
Berkeley

Published in the United States by Watson-Guptill Publications,
an imprint of the Crown Publishing Group, a division of Random
House LLC, a Penguin Random House Company, New York.
www.crownpublishing.com
www.watsonguptill.com

Library of Congress Cataloging-in-Publication Data
Crilley, Mark.
 The realism challenge : drawing and painting secrets from a
modern master of hyperrealism / Mark Crilley. —First edition.
 pages cm
 Includes bibliographical references and index.
1. Photo-realism. 2. Drawing—Technique. 3. Painting—Technique.
I. Title.
 N6494.P42C75 2015
 751.4—dc23
 2014024085

Trade Paperback ISBN: 978-0-385-34629-0
eBook ISBN: 978-0-385-34630-6

Printed in China

Design by Katy Brown and Debbie Berne

10 9 8 7 6 5 4 3 2 1

First Edition

This book is dedicated to my wife, Miki,
and to our children, Matthew and Mio.

CONTENTS

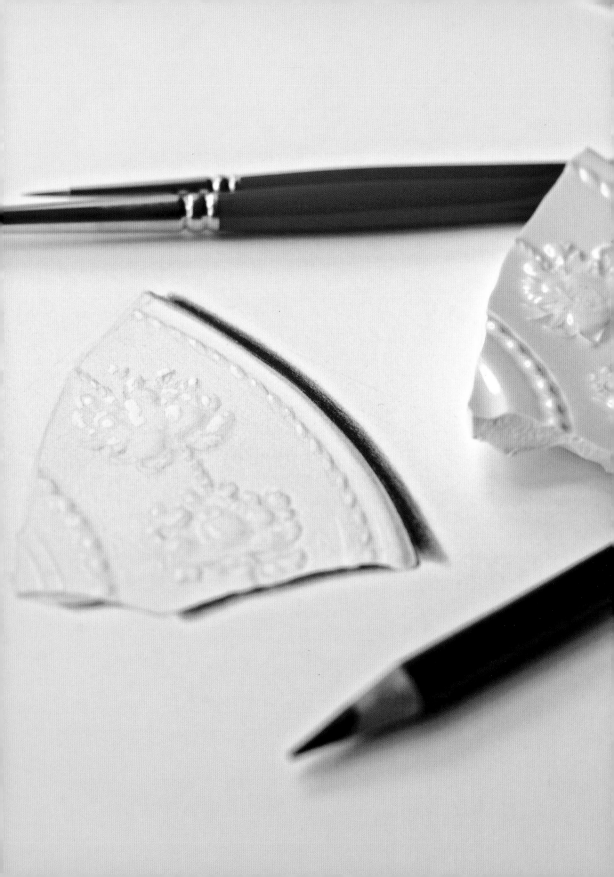

Introduction

A few years ago, I uploaded a video to YouTube called "Realism Challenge: Crumpled Paper." It opened on a small sheet of white paper on the left-hand side of the screen, which I picked up and lightly crumpled. The remaining two minutes of the video were devoted to me doing an illustration in time lapse—right there beside the crumpled paper—of that very same object.

It was a simple enough idea. But something about it captured people's attention. It got hundreds of thousands of views, prompting me to try a similar exercise, this time with a sliced mushroom in place of the crumpled paper. When that one proved equally popular, I tried a third—this time with a torn-up playing card. That one proved the most popular of them all; as of this writing, it has had more than six million views. I began to understand that these videos were supplying people with a visual experience they'd probably never had before.

Was I doing something new in these videos? Well, yes and no.

It is common enough to see a seemingly three-dimensional object that is, in fact, a painting. Indeed, examples of "trompe l'oeil" painting—images designed to fool the eye in this way—can be found as far back as Greek and Roman times. An artist creating a mural in ancient Pompeii may have playfully painted an open window where in fact none existed. Such exercises in hyperrealistic trickery have continued over the centuries right up to our own times. So no, there is nothing new about an artist painting something at actual size in an effort to make it seem real enough to reach out and touch.

But seeing an artist go up against a real object—one that remained right there in full view as the artist worked—that was something relatively new. By leaving the object in view, I put myself to the ultimate test of capturing reality. I invited the viewers to compare the two—object and illustration—with their own eyes and say to what degree I had succeeded or failed.

And yet I had the nagging feeling that this "realism challenge" thing could be more than mere video entertainment. It was an opportunity to pull back the veil and allow people see how illustrations are made, from beginning to end. I'll bet you've had the experience of looking at a realistic painting and asking, *How did they do that?*

It seems to me you're entitled to an answer to that question. There's no reason why it has to remain a mystery. I know how it's done because I've done it. I want you to know, too, and that's why I decided to make this book.

In these pages, you will find thirty "realism challenge" lessons. Each begins with a photograph of the "target object"—the item to be re-created in illustrated form. From there, you will see the key steps in the illustration process, each explained to you as clearly as possible in easy-to-follow terms.

It's not enough for an artist to glibly tell you that the process consists of looking at an object and drawing it. You need to know which art supplies were used. You need to know the order in which those tools were applied. And you need the illustrator to call your attention to what you're seeing—to tell you what changes were made from one step to the next and why. I will do all of these things in the pages ahead.

Can I guarantee magical results for the aspiring artist who has a lot of ambition but little patience? No. But if you can draw what you see with some accuracy, there's no reason why you shouldn't be able to learn the art of the "realism challenge."

Art teachers often say, "You need to know the rules in order to break them." Press those same teachers to tell you what the "rules" really are, and they may fumble a bit as they answer. But one thing's for sure: acquiring the ability to draw every detail of an object that stands before you—to capture the way its shadow hits the ground or the way light glints off its surface—is a worthy goal. Humans have sought to master it since the dawn of time.

So here's to you and your realism challenges. Nothing would make me happier than knowing that I've helped you unravel the mystery of *How did they do that?* You must promise me this, though: promise me you'll go beyond knowing how they did it to doing it yourself.

Art Supplies

I've always felt that people fixate a little too much on art supplies. It's tempting to think that if you go out and buy the same materials that a professional illustrator uses you will gain some kind of huge head start toward achieving similar results. But you can't buy skill. You can't buy years of practice. You can't buy the ability to see what's working in your illustration and what isn't.

So my advice is to go to your local art store and get reasonably priced art supplies. Sure, you don't want the kind of cruddy art supplies they sell at the corner drugstore. But unless you're already a paid professional, there's no need to blow a thousand dollars or more buying top-of-the-line materials. The people at the art store should be happy to guide you toward art supplies that will get the job done without emptying your wallet.

PAPER

One place where beginning artists do tend to sell their own artwork short is in the realm of paper. The illustrations you see in this book could never have been done on flimsy office paper. Watercolors cause that paper to wrinkle into a soggy mess. What you need is smooth-surface Bristol board. This sturdy paper is the thickness of card stock or poster board. It will hold up to the wear and tear of the illustration process. I buy it in 11-by-14-inch pads, twenty sheets at a time.

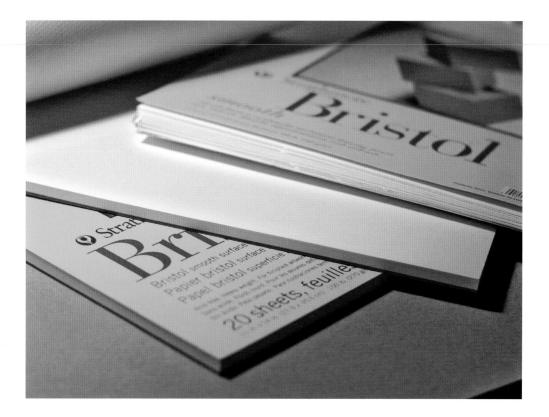

Just make sure you get the smooth-surface variety. A rougher vellum–type surface will make it hard for you to do detailed work with your colored pencils.

WATERCOLORS

I would advise steering clear of the watercolor sets that have rows of little dried watercolor "cakes" embedded in them. These are almost always of very poor quality, and you will be struggling forever to get a good solid hue from them. Have your local art store people direct you to their section of watercolors in tubes. You may get a little sticker shock with these, as they can quickly become very expensive. Most stores will stock student-grade watercolor tubes,

though, and these should help you stay within budget.

All artists have their preferred color types. I'll tell you the colors I use, but you should feel free to experiment and find the mix of colors that works best for you. I've listed the colors with their "official" name first, followed by a plain English explanation of what the color looks like.

ALIZARIN CRIMSON: a deep, dark red

CADMIUM RED: a warmer red, leaning toward orange

CADMIUM YELLOW: a deep "school bus" yellow

LEMON YELLOW: more of a true yellow (to my eyes)

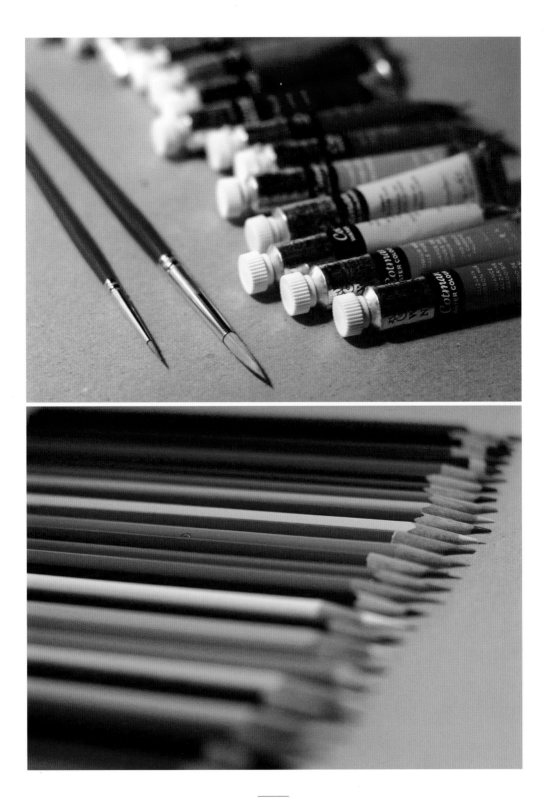

- **SAP GREEN:** a yellowish green
- **VIRIDIAN:** a darker green, leaning toward blue
- **ULTRAMARINE BLUE:** a deep blue, leaning toward purple
- **CERULEAN BLUE:** a lighter "sky" blue
- **DIOXAZINE PURPLE:** dark purple leaning toward red
- **BURNT UMBER:** a warm brown
- **BURNT SIENNA:** brown with a hint of red
- **YELLOW OCHER:** a brownish yellow
- **PAYNE'S GRAY:** a dark gray
- **IVORY BLACK:** pure black

BRUSHES

All of the watercolor work you see in this book was done with just two brushes: a size 0 and a size 6. The size 6 is a thicker brush, which I use for larger areas that I need to cover with as few strokes as possible. This brush can give you a surprising amount of precision as well, but when you get to the really fine details, you'll need to switch to the other brush. The size 0 brush excels at making razor-thin lines and dropping tiny little highlights right where you need them. I'm sure many artists work with a much wider variety of brush sizes than I do. But in my experience, these two are all you need for creating illustrations of the sort you see in this book.

COLORED PENCILS

A good set of colored pencils shouldn't set you back too much. It all comes down to how many colors you want. I'd say I used something in the range of thirty or forty different colored pencils in creating the illustrations in this book. (I've collected quite a boxful of them over the years, so it's a little hard to tell!) When shopping for colored pencils, make

sure you get plenty of muted colors, like grays and browns. These are the colors you will use over and over again, while colors like purple and turquoise—hues less common in nature—don't often come into play.

The colored pencil company I use sells two different types of pencil: one with a harder lead and one with a softer lead. If you have to choose between the two, I'd advise you to go for the harder lead. It allows for more precision, as it keeps its fine point for a longer time between sharpening. Otherwise, any decent set of colored pencils sold in an art store should serve you well.

WHITE GOUACHE

I wish I could say watercolors and colored pencils are all you have to get. They are certainly the key materials, comprising 95 percent of the lessons in this book. But there is one final art supply that's essential: white gouache. This opaque white paint allows you to drop in the bright white highlights that are a crucial finishing touch for many of these exercises. Happily, a single tube is all you need, and it doesn't cost much.

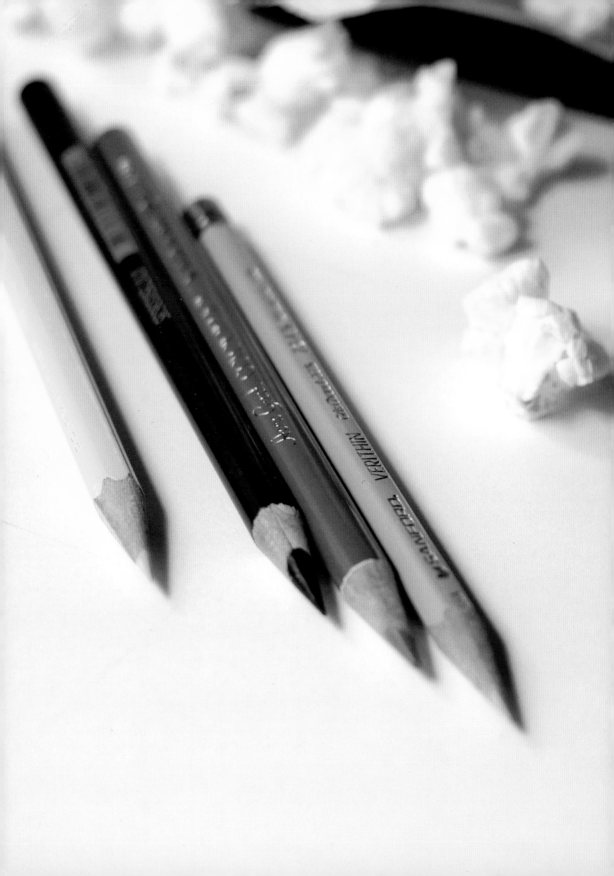

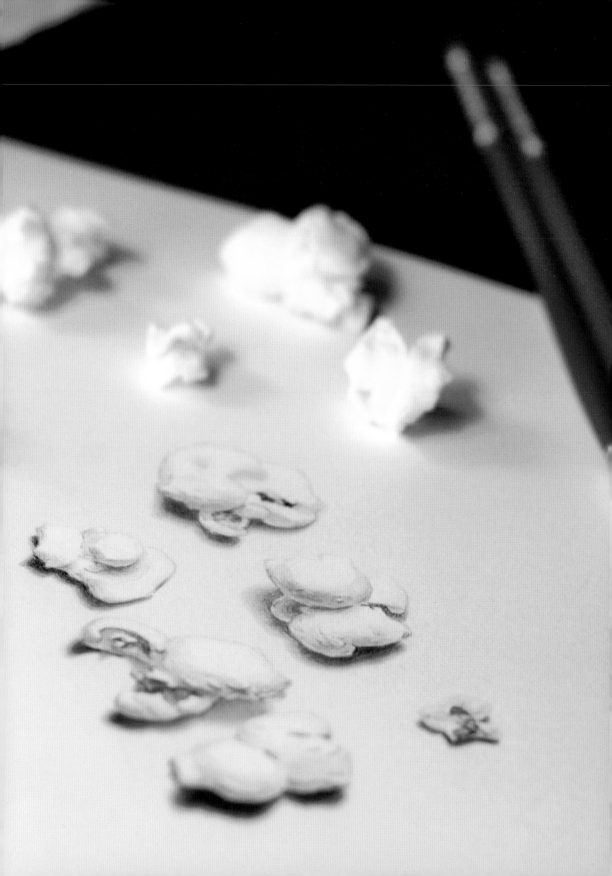

Simulating Shadows

Painters have long understood that the key to making something appear three-dimensional is to capture the effect of light falling upon the object depicted. The wise artist devotes just as much attention to rendering the shadows as to drawing the object itself. In this first chapter, I will focus on showing you how to illustrate shadows, using common household items like paper and popcorn.

Torn Paper

I knew I had to choose my first target object carefully. Even the most humble everyday item can transform into an artist's nightmare when it comes time to illustrate it. There will be plenty of time for dealing with colors, surface textures, and shiny highlights in the later lessons. Instead, let's start with a simple torn piece of white paper. This way you can focus on just two things: getting the shape right and rendering the shadows.

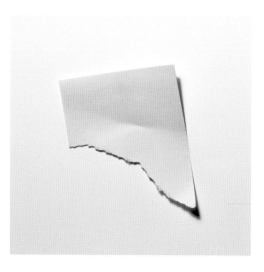

1 Arguably, the most important step in any of these lessons is the first one: drawing the basic lines of the target object in pencil. If you have never before attempted to draw an item exactly as you see it, you will need to spend some time acquiring this skill. Use a ruler to measure the torn piece of paper to make sure your pencil drawing of its contour is exactly the same size. Keep your lines light. Later on you will need to erase some of them.

2 Depending the location of the light source, there should be at least one shadow cast by the straight untorn edge of the paper. Using a combination of black and gray colored pencils, add this little sliver of darkness to your illustration. Very often a shadow is not an unchanging black shape but rather an area that is darker in one part and lighter in another. See how this shadow is a bit lighter near its top? Rendering that change in darkness is crucial for conveying a sense of realism.

3 Now let's move to the torn edge of the paper. Consider this step as the first test of your patience as a hyperrealistic artist. It may be tempting to speed through the process and just toss in a dark, jagged strip that is more or less exactly the same as the line it is next to. Look closer though. Is the shadow narrower in some places than others? Does it break into separate bits? Is it darker near the paper's edge than it is everywhere else? Your job is to take your time and capture all of this in your drawing.

4 Continue until you have completed the entire shadow. In the case of my target object, one tip of the torn edge curled up a bit from the Bristol board beneath it. This created a larger, darker area of shadow that grew more soft edged as it receded from the paper. This meant using the black colored pencil in one part of the shadow and gradually blending it into the gray colored pencil in the other.

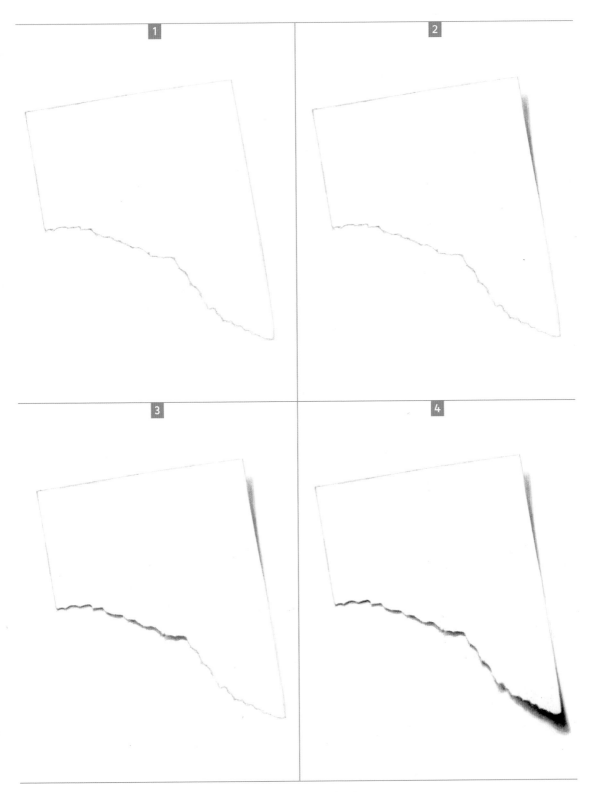

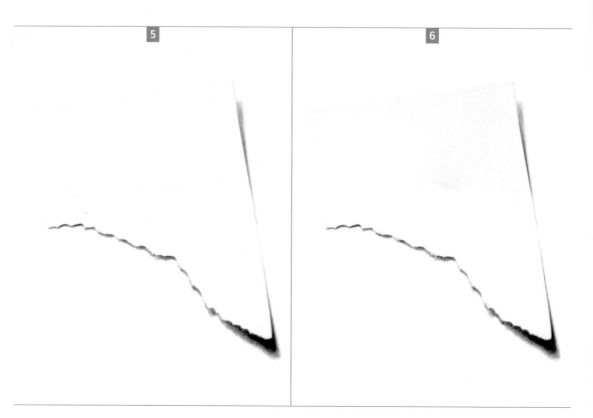

5 Next, turn your attention to varia-
tions in the surface of the paper. Even
a smooth sheet of paper may appear a bit
more gray on one side than the other, if
there is a slight curve in its surface. Using
careful circular motions with a light gray
pencil, you can capture this subtle change
in your illustration. In my case, the paper
had a hint of a crease in it, so that area
required a somewhat darker gray.

6 Continue working into the surface
of the piece of paper until you have
captured the full extent of its various color
shifts. The more time you put into this
final polishing phase, the more you will be
rewarded with a convincing final result.

THE FINISHED PIECE Congratulations! You've just completed your first realism challenge. Are you ready to take it to the next level?

Crumpled Paper

You may be tempted to move on to something more challenging, but let's stick with paper as the target object for one more lesson. Trust me: even for a seasoned professional, accurately rendering a crumpled piece of paper can prove plenty challenging. With this in mind, I have taken a small piece of white paper and folded it in on itself just a bit, then flattened it with the palm of my hand. This provides a few simple "origami–like" folds that will allow you to practice shading in a more sophisticated way than in the previous lesson.

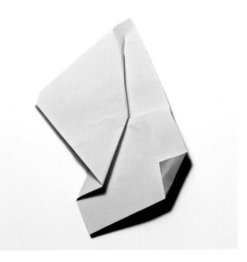

1 Begin with a pencil drawing of just the contours of the piece of paper. Measuring with a ruler will help you make sure your illustration is the exact same size as the target object. If you are tempted to simply trace around the edge of the crumpled piece of paper to create your contour line, go right ahead. Anything that helps you get a good final result is fair game in my book.

2 Now move on to the interior lines of the object. Observe not just the lines themselves and the directions they point in, but also the various shapes they create. These areas of "negative space" are one of an artist's most valuable drawing tools. By recreating all the various polygons I saw within this crumpled paper, I was able to get all the lines right where they needed to be. Remember to keep your lines light so that you can erase them a bit later on if needed.

3 Begin rendering the shadows. Since I am right-handed, I chose to begin at the upper left corner of the image and work my way down toward the lower right, to avoid resting my hand on the artwork I had already completed. If you are left-handed, you will want to use the opposite approach—upper right to lower left—to achieve the same results.

4 In my case, there was a "dog-eared" triangular fold on the lower right-hand corner of the paper. In illustrating this area, I paid careful attention to variations in darkness, taking pains not to settle for a solid, unchanging gray, since my eye told me that several different shades were required.

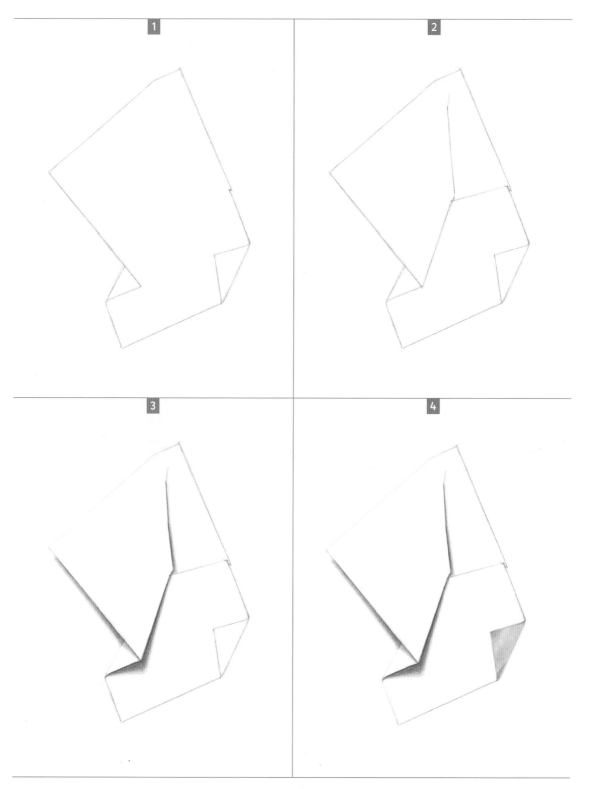

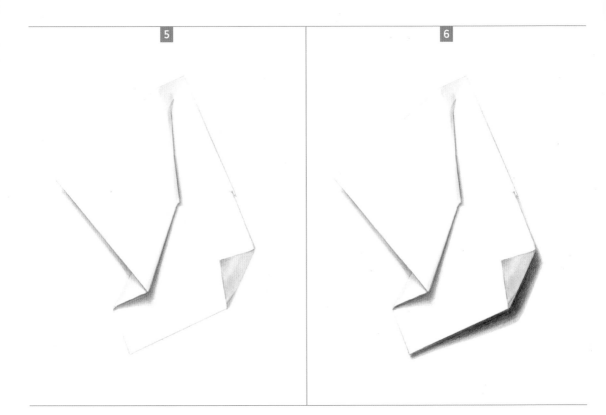

5 For me, the fun part of any realism challenge is the subtle stuff. In the upper right-hand corner of the paper, I observed a slight crease that resulted in a gradual transition from light gray to white. Similar seemingly minor fluctuations in gray occur in other areas as well: that small triangle of space where you can see the other side of the paper, for example. These tiny details make all the difference in the end. Take your time and reproduce as many of them as you can in your illustration.

6 Finally, it's time for the drop shadow: the bits of shadow the object casts upon the surface beneath it. As always, it's key to capture the differences in darkness as well as getting the proper size and shape. See that band of pale gray near the shadow's edge? Get that in your illustration and you'll find your drawing becomes something that really pops off the page.

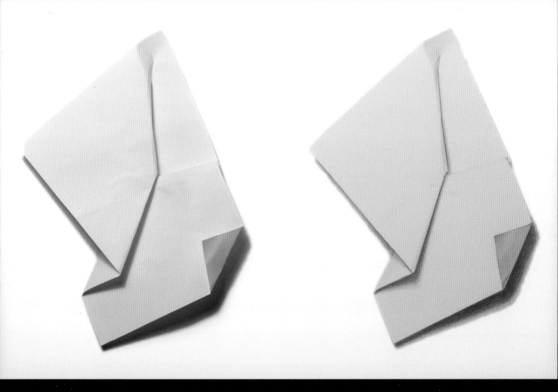

THE FINISHED PIECE You're done! If you feel you need more practice before moving on to greater challenges, just start over with a new crumpled piece of paper. Like snowflakes, no two are exactly alike, and every one you do will heighten your powers of observation.

Initial Line Work

Getting your line drawing right is crucial. Everything else is built on top of it, after all, so any mistake made at this stage becomes a permanent error in the illustration. I'm a big believer in measuring things with a ruler rather than just "winging it." But even without a ruler, you can train your eyes to see where lines need to be relative to other lines you've already drawn. For example, before rendering a horizontal crease in a piece of paper, define its location relative to the top and bottom of the image. Is it exactly at the halfway point? A bit higher? A bit lower? Every line you draw has a particular length, a particular angle, and a particular location within the picture. Only when you understand all three of these things should you actually add the line to your drawing.

Shattered Eggshell

This lesson requires a bit more preparation than the two previous examples, but it's well worth the extra effort. Take an ordinary white-shelled egg and, after popping a good-sized hole in both ends with a knife, blow the contents out to make it completely hollow. Then simply crack it open to whatever degree you like. The more pieces you create, the more time consuming this realism challenge will be.

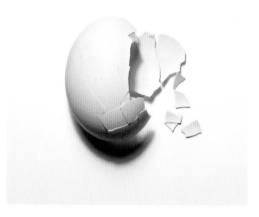

1 Draw the contours of the egg in pencil, taking care to replicate both the shapes of the various pieces as well as the shapes created by cracks in the surface of the shell. This stage is all about observation. You may be tempted to stop looking at the target object and just draw the cracks any which way you like, but if you take your time and reproduce them carefully, you will get a much better final result.

2 After switching to a gray colored pencil, begin adding shadows. I chose to start with an area of shade in the interior of the cracked–open egg. Note that this shadow is darkest on its left-hand side and gradually grows diffuse on its right-hand side. Capturing these subtle differences is crucial to conveying a sense of three-dimensionality.

3 Staying with gray colored pencil, continue adding shading across the entire surface of the egg, constantly comparing the darkness of your artwork with the corresponding areas on the target object. My approach is always one of caution—building the color up little by little.

4 Once you have the easily observed areas of darkness locked down, it's time to move on to matters of greater subtlety. See how the whiteness of your paper reflects light upon the lower edge of the egg? Devote extra attention to areas like this: the shading on the surface of the egg has a light–dark–light pattern to it; if your drawing lacks this shading, it will be unconvincing.

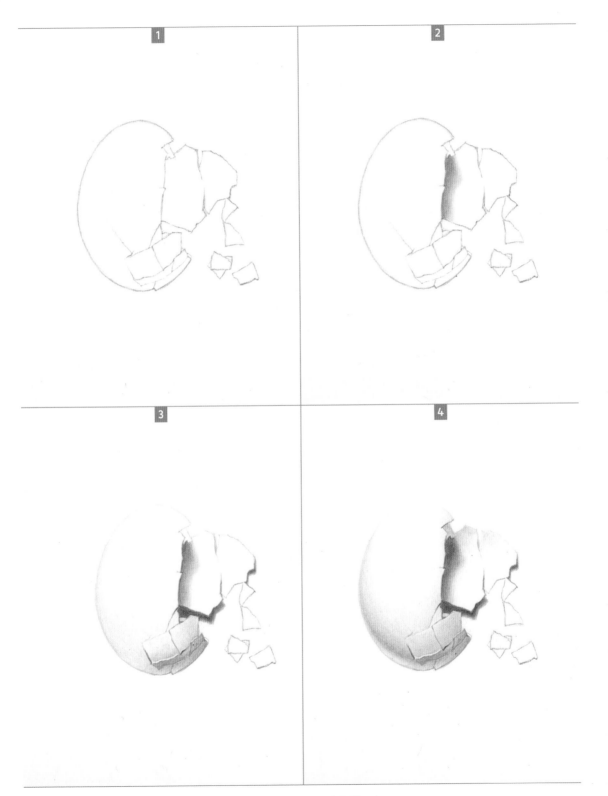

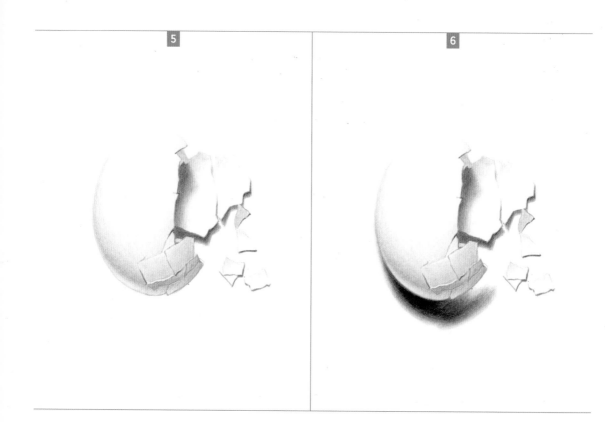

5 Now it's time to turn your attention to the tiny pieces of eggshell broken off from the egg itself. There are, of course, the drop shadows to contend with: they are dark and quite sharply defined, as the eggshell pieces lie nearly flat on the surface. But just as important are the light gray tones of the eggshell pieces themselves. Because they are all slightly curved you may find that they are more shaded on one side than the other.

6 Pull out a black colored pencil to begin working on the drop shadow of the egg itself. As always the darkest part of the shadow is nearest the object. If you left your egg largely intact as I did, you will find that the shadow has great variety in its coloring. This is because the white surface of the egg's shell reflects light back into its own shadow. Capturing little details like this is what separates the "close but not quite" realism challenge from the one that makes people say, "You nailed it."

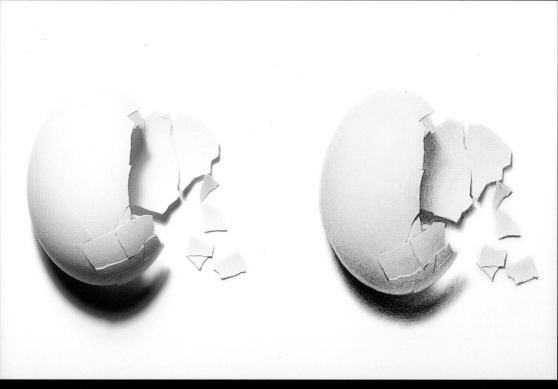

THE FINISHED PIECE If you want to take your illustration to a higher level, add highlights with white gouache. It may seem odd to put white paint on top of paper that's already white, but the color of the gouache is actually more of a "pure" white than that of the paper. It's very subtle, but you can see the difference when you compare the little pieces of shattered eggshell to the paper surrounding them.

Popcorn

The more colors there are in an object, the more difficulties it presents to the artist trying to reproduce it. A good way to dip your toe into the waters of full-color artwork (rather than cannonballing right into the deep end!) is to try illustrating a few pieces of popcorn. The remains of the kernel shells will require colors ranging from brown to yellow, and there may even be a superpale base layer of yellow for the "white" of the popcorn itself.

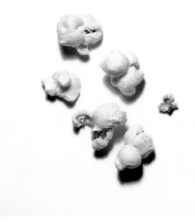

1 Begin by penciling both the contours and the interior lines of each piece of popcorn. You may find yourself surprised—as I was—by the sheer variety and complexity of the forms. They're like little sculptures, each one unique. Take your time and get the shapes and sizes as close as you can to the originals. Measuring with a ruler may help.

2 I observed a faint yellowish tint to my popcorn, so I opted to replicate that shade in watercolor. Watercolor can "set" pencil lines into the paper, making them impossible to erase, so its best to lighten the pencil lines up quite a bit before going over them with the brush. A pale shade of yellow is easily created by diluting yellow watercolor paint with copious amounts of water. Test the color on a scrap of Bristol board to make sure it's the right shade, before carefully brushing it onto your various popcorn shapes.

3 Sticking with watercolor, I added a pale shade of yellow to all the areas where husks were visible. This is what I would call a "base layer." I'm not attempting the final color as I see it in the target object, but instead getting something down that I can build upon later. In a similar fashion, I mixed a pale shade of gray to begin indicating shadows on each piece of popcorn. You can see I took on a few of the details at this stage, but left most for later.

4 It's time to set the watercolor brush aside and switch to colored pencils. Alternating between a light gray colored pencil and a dark gray one, I confined my attention to the shadowed surfaces of the "whites" of the popcorn. The amount of control afforded by a colored pencil makes it the ideal tool for rendering the various nooks and crannies found in these surfaces—some bold and easy to see, others quite subtle. It's interesting that even at their darkest, these parts of the illustration require only dark gray rather than black.

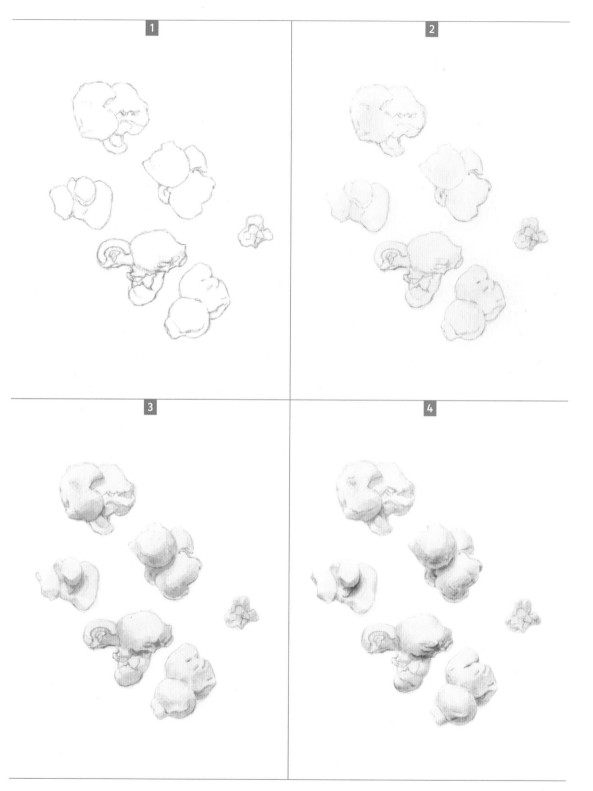

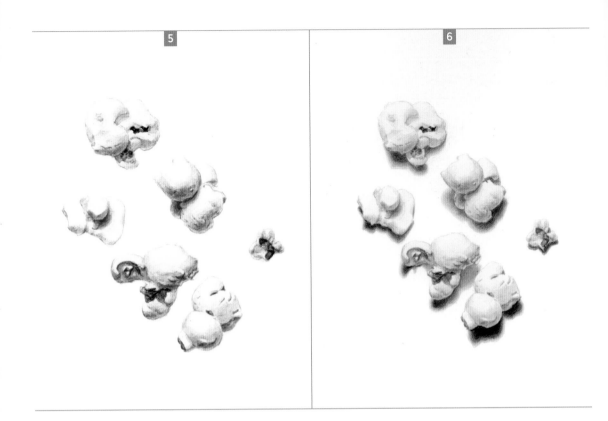

5 For the final details of the kernels, I chose to return to watercolor—carefully adding various shades of yellow, orange, and brown. My approach with watercolor is almost always to work from light to dark, and you can certainly see that on display in this lesson. Step 2's yellow was extremely light. Step 3's shade was a touch darker. Only now, in step 5, do I begin adding darker shades of brown. The rationale is simple: it's much easier to make a light area darker than it is to make a dark area lighter.

6 Switching back to colored pencil, you can now begin adding the drop shadows. I was struck by the variety in the shadows, ranging from very pale gray to jet black. One of the pieces of popcorn even had a bit of yellow reflected in its shadow from another piece nearby. I added that yellow tint into the shadow with a bit of watercolor.

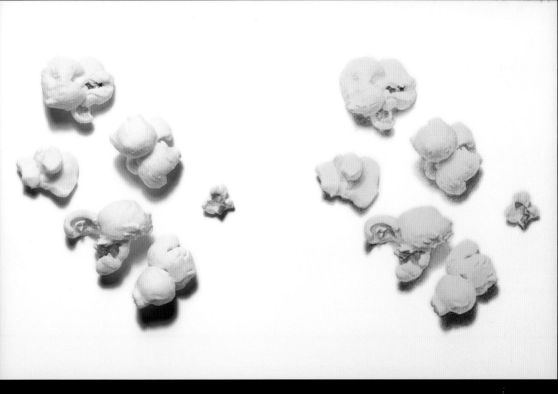

THE FINISHED PIECE You may find that final details remain that you missed along the way. Take some extra time at the end of the process to see if there are any remaining discrepancies between the pieces of popcorn and your illustration of them. Congratulations!

Mushroom

Let's continue venturing into the world of full-color illustration with a common mushroom. Like the pieces of popcorn, a white mushroom requires just a few touches of watercolor—enough for you to get a feel for mixing up a bit of brown and yellow, without having to plunge headlong into the demands of a full-color piece. Grab your kitchen knife and the nearest mushroom: you're ready to slice up the subject of your next realism challenge.

1 I chose to create two slices of mushroom and lay them one upon the other, but if you're nervous about taking on too much, you may want to stick with just one slice. Either way your job at this penciling stage is to get the shape of the mushroom just right. This means paying careful attention to the spaces between the lines, as well as to the length and direction of the lines themselves.

2 Assuming your white mushroom looks like mine, you'll use four different colors at this stage: light yellow, brown, light gray, and black. Begin by mixing up a very watery shade of yellow for the stem of the mushroom. Apply the color in smooth, steady strokes, and then let it dry. Next, move on to the brown areas and then the grays, taking care to keep the grays especially light by mixing in plenty of water. Finally, after everything else has dried, add the darkest touches in black.

3 Now pull out your colored pencils and start the shading. I used a dark brown pencil to add definition to the pockets of brown found in the head of the mushroom, and then let up the pressure on that same pencil to create subtle areas of shading nearby.

4 Continue with the colored pencils, now turning your attention to the details. My approach is always to work from light to dark, saving the jet black bits for last. You may find that you want to trade back and forth a bit between colored pencils and watercolors. It's never too late to add watercolor when you think an area needs it.

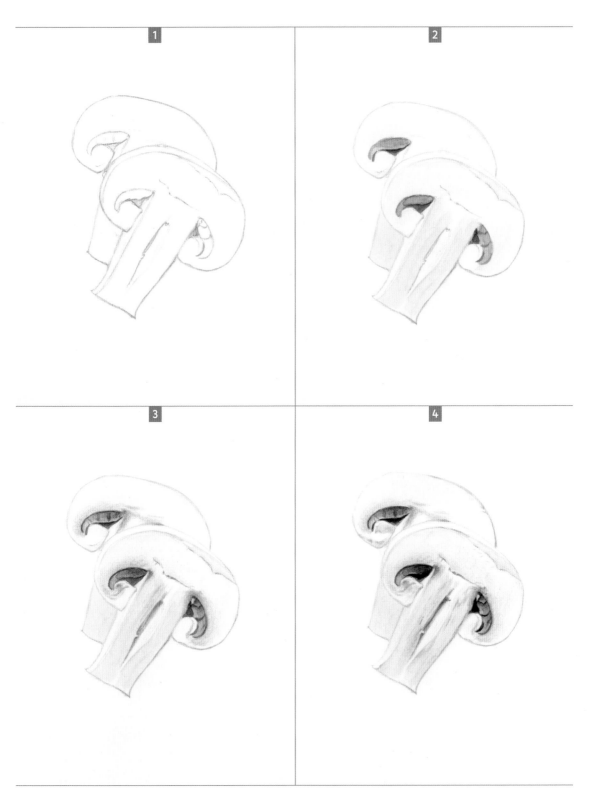

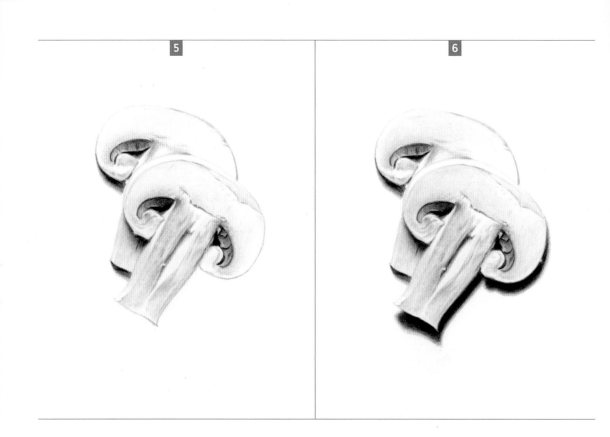

5 When you feel the mushroom itself is largely complete, it's time to move on to the drop shadows. You may want to use as many as three different colored pencils for the area of shadow—black near the mushroom's edge, then a midgray, and finally a light gray as you work your way out to the place where the shadow dissipates into the white of the paper.

6 Once you complete the drop shadow, you may choose to add a few last highlights with white gouache. I confined mine mostly to the upper edges of various parts of the mushroom—places where light glinted off the mushroom and created a tiny area of pure white. These final touches can make a surprisingly big difference in conveying a sense of three-dimensionality.

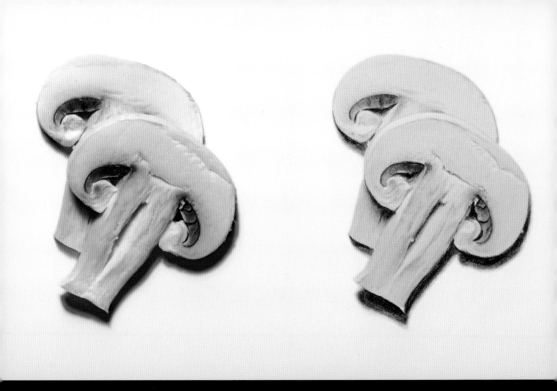

THE FINISHED PIECE By now, you should start to feel a bit more confident about doing full-color pieces. In the lessons ahead, I will show you how to gradually work toward illustrations in which more and more color comes into play.

Adding Color

Many beginning artists view adding color to a picture as anything from tricky to flat-out disastrous. Happily, the combination of watercolors and colored pencils offers a pretty gentle path into this realm, sidestepping the considerable challenges presented by a medium such as oil paint. In the chapter ahead, you will take gradual steps toward mastering color, starting with muted hues and working toward more dramatic colors.

Piece of Cardboard

Once you start doing realism challenges, you may find yourself taking a good long look at objects you might otherwise toss in the garbage. A good example is a scrap of corrugated cardboard—the kind you can tear from the side of any ordinary shipping box. A piece like the one shown here can make an ideal subject for venturing further into the world of full-color illustration. It forces you to cover the entire picture with a more "committed" layer of color, but simplifies things by asking you only to match various shades of brown.

1 Begin by drawing the contours and interior lines of the piece of cardboard lightly in pencil. In my case, the corrugated ridges had become visible on the left-hand side, so I took a moment to count the number of ridges and make sure that I had the exact same number in my illustration. Irregularities in the smoother cardboard surface were so subtle I chose not to attempt them in pencil, but rather to save them for the later coloring stages.

2 This next step requires two distinct shades of brown watercolor. For this example, I began by covering the entire surface with the lighter shade, and then added a second layer of the darker brown along the left-hand side. Remember to always test the colors you've mixed on a scrap of Bristol first, before committing them to the final art. I observed a small "tuft" of lighter cardboard remaining in the lower left of the corrugated section, and so I made sure to leave a patch of the lighter brown in that area.

3 I now turned to brown colored pencil to add shade to the corrugated area of the cardboard. No two of these little "valleys" were identical, so I took my time and worked at replicating each one, focusing on both the shapes as well as their levels of darkness. I found that each strip of shading here was dark and crisp along its upper edge, lighter and more diffused along its lower edge.

4 Sticking with brown colored pencil, I turned my attention to the rest of the cardboard's surface. Here the shading required is considerably more subtle. The paper seems to ripple here and there, due to the corrugated structure underneath, so I gradually built up superlight strips of shade in those areas. Even the diagonal crease—a straightforward line at first glance—proved rather more complex upon further examination. It fractured into at least three separate lines, so I took care to reflect that in the illustration.

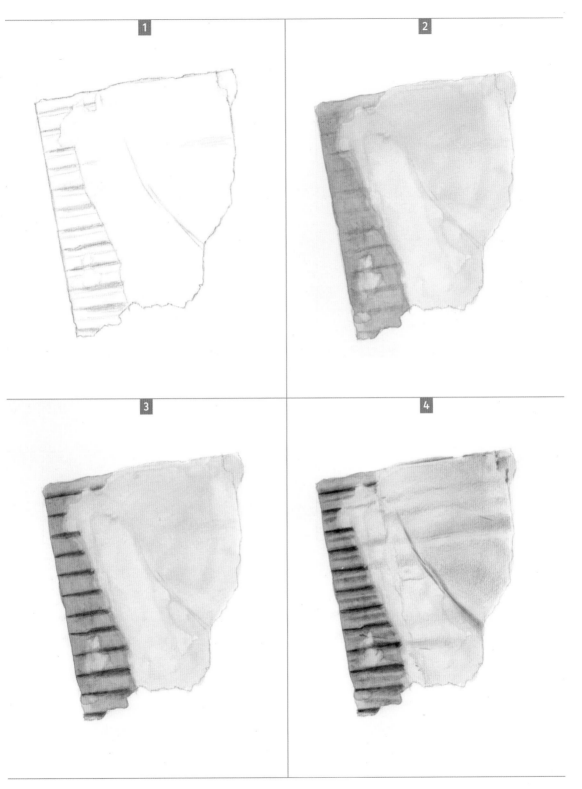

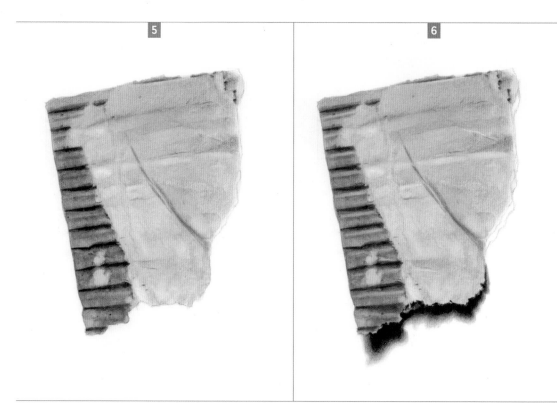

5 Let's refine things further. Though I'd tried to match the darkness of the corrugated area when I first rendered it in step 2, I could see that it was still too pale. So I mixed up a bit more brown watercolor and added another layer to the entire area, taking the opportunity to tighten up the dividing line where the lighter paper was torn away. Similarly, I continued building up the tone of the right-hand side of the cardboard, choosing a mix of watercolor and—after the paint dried—a bit more colored pencil to achieve the effect.

6 Sometimes the highlights you see in your target object are not crisp, bold white ones. That is certainly the case with cardboard, so instead of using gouache for the lighter areas I chose to use a white colored pencil. This way I could replicate the "matte-finish" highlights of the corrugated area, as well as capture the subtle, undulating surface on the right-hand side of the cardboard. Once I finished that, I began working on the drop shadow with black and gray colored pencils.

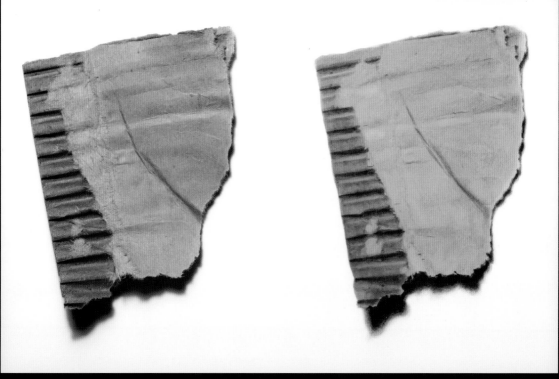

THE FINISHED PIECE A little more work on the drop shadow was all it took for me to bring this challenge to completion. Next time you're about to chuck a cardboard box into the recycling bin, give it a second look: that's not garbage, it's a work of art!

Light to Dark

Throughout this book, you will see that my approach to coloring an illustration is to start with light colors and build gradually toward darker ones. The logic behind this is plain: it is vastly easier to make a light color darker than to make a dark color lighter. This is especially true when one uses watercolors, since they lack the opacity of oil paint and other such media. Artists who have worked for many years acquire the ability to envision the final image without attempting to leap immediately toward it. Indeed, they know that slapping down a dark shade of paint at the outset of the process could be an irreparable mistake. For my part, I feel a certain freedom in these early stages, knowing that it's okay to keep the colors light and tentative. Committing to a bold, dark color at the very beginning is like doing a trapeze act without a net. Impressive enough if you pull it off, but very painful if things go wrong!

Seashells

Next time you're at the beach, you may find it's the perfect place to find objects for your next realism challenge—after you've relaxed and enjoyed yourself, of course! Seashells offer a variety of interesting colors, patterns, and surface textures, all of which make them a good source of practice for honing your illustration skills.

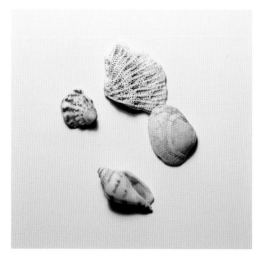

1 Arrange your shells as you like and pencil their contours onto the paper. As always, making measurements with a ruler can help you get sizes and shapes right. If taking on three or four different shells seems too much, why not just start with one instead? There's nothing wrong with focusing on quality rather than quantity.

2 Once you've got the lines in place, lighten them up a bit with an eraser so that dark pencil lines don't become part of your finished illustration. Then mix up some very pale colors to form a base layer for each shell. In my case, the colors were all various shades of yellow. The key is to keep things light so that you can gradually build on top to reach the final shade you need.

3 I examined my shells and felt the best next step was to switch to colored pencil for some surface details. An orange-brown shade allowed me to replicate the pattern on one shell, while a gray colored pencil was used for replicating the fossil–like texture on another. Take a good look at the shells you've chosen and select the appropriate colored pencils for rendering the surfaces of each.

4 Continue until you have the basic patterns and textures of each shell. Depending on the degree of detail, you may find you need to sharpen your pencils quite frequently. The fanlike pattern on one of my shells required narrow, tightly packed lines. I couldn't have done them justice with a pencil that had lost its fine point.

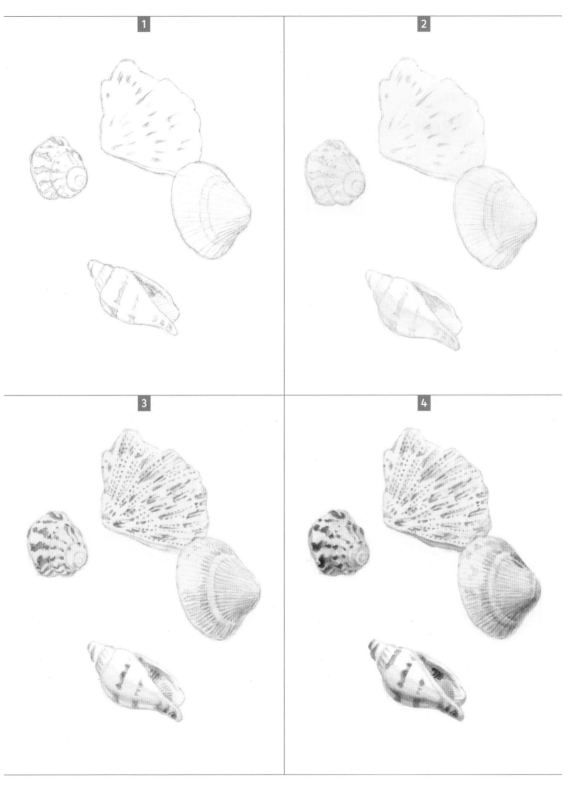

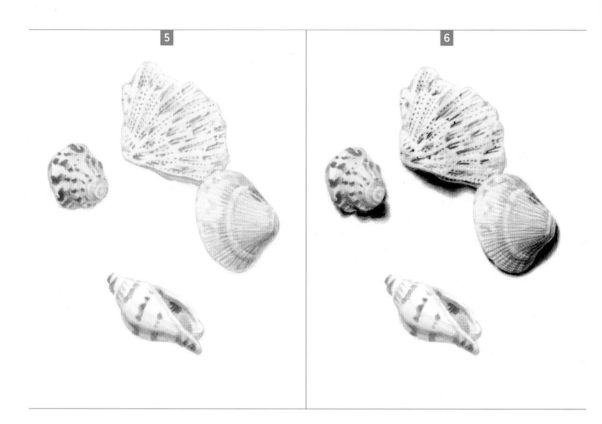

5 Chances are the colored pencil hasn't covered the full range of detail for each shell. No problem: just pull out the watercolors and add extra layers of color, tightening things up throughout. I found most of my shells had noticeable hints of yellow in various areas, so I mixed up a bit of pale yellow paint and used it on all four shells. I often switch back and forth between colored pencil and watercolor several times before I feel the job is done.

6 Now add the drop shadows. I generally stick with colored pencil for my drop shadows, since I find it's easier to create a gradual fade from black to white. Watercolor tends to produce a crisper edge, but you should feel free to experiment and find the approach you like. Indeed, you may find that a combination of the two works best for you.

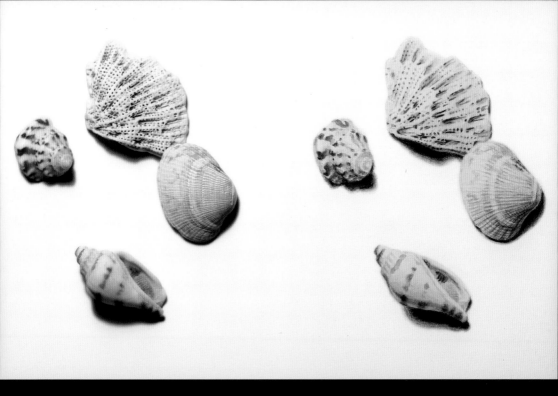

THE FINISHED PIECE My shells were not especially shiny, so there was no need for bold white highlights. Still, I worked a bit of white gouache into a couple of the shells where I wanted them to "pop" a little off the paper. Time to kick back and relax: you're done.

Cookie

I'm pretty sure no one needs an extra reason to like cookies, but here's one anyway: they make for excellent realism challenge subjects. Why? Because their surfaces tend to feature loads of texture. In many ways, a texture-filled surface is, oddly enough, easier to illustrate than a perfectly smooth surface. Minor imperfections of technique are easily camouflaged by a high-texture surface, whereas in a smooth surface they have nowhere to hide.

1 As always, begin by penciling the contours and the most important details of the target object. I chose a chocolate chip cookie not just because they're delicious (honestly!), but because I knew the contrast of light and dark brown would result in a more interesting picture. This drawing, complex as it is, doesn't attempt to replicate every last speck of detail in the cookie's surface. I've singled out the most important dark areas and focused on them.

2 Mix up a bit of watercolor to match the basic color of the cookie as best you can. In contrast to some of the other lessons in this book, my base layer of watercolor is slapped on pretty casually here. Knowing how much texture is yet to come allows me to not sweat the details at this early stage. For now, all you need is to get something down that covers the white of the paper.

3 If your cookie has chocolate chips like mine did, now's the time to color them in with dark brown watercolor. Again, this is a bit different from the "save the dark bits for last" approach you'll see me use in other lessons. I want to use the chocolate chips as guideposts of a sort: if I get them all in place right now, they'll help me locate the more subtle surface details—the tiny specks of ocher and brown that float between them—in the later stages.

4 Time to set the brush aside and switch to colored pencil. The grainy look of colored pencil can be a drawback in some situations, but here it is the very thing needed. But colored pencils will probably not be able to do the job all on their own. That's why you'll see a few dabs of brown watercolor in there as well. The two media together can capture the highly varied surface of the cookie in a way that neither of them would be able to do separately.

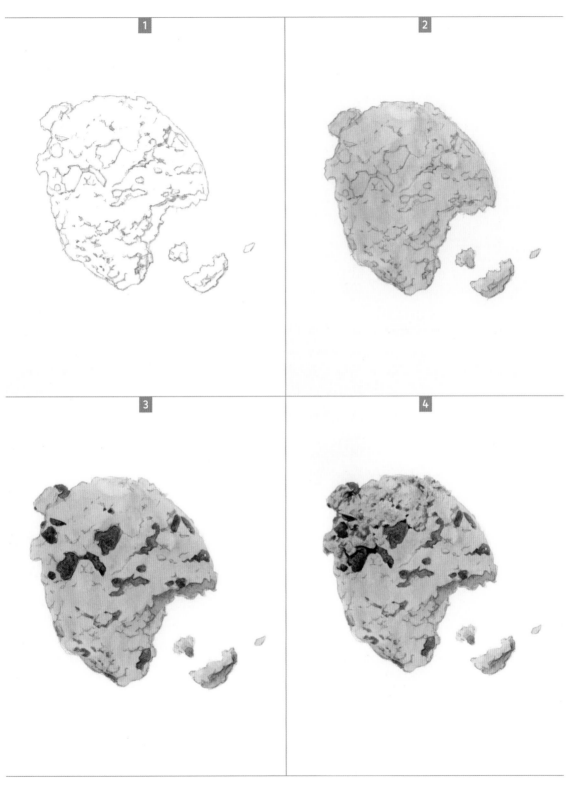

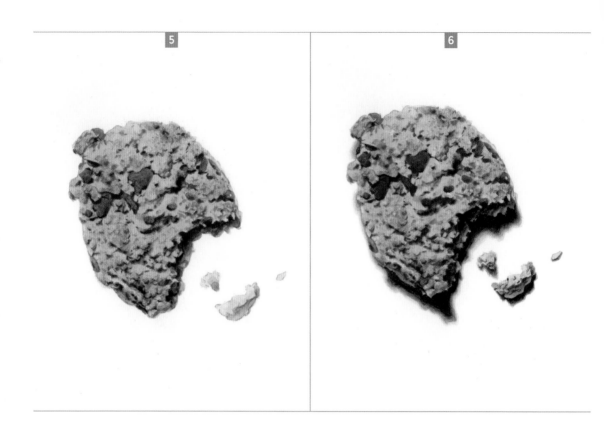

5 Continue working until you've repli-
cated the entire surface of your cookie.
I won't lie to you: this is time-consuming
stuff. You have to keep comparing your
illustration with the target object to see
each and every detail. You must always
check the darkness of the watercolor paint
in your brush to make sure it's neither too
light nor too dark. Success in this realism
challenge depends on patience. If you feel
your patience flagging, take a break and
come back to the illustration later.

6 You're nearly there. Add the drop
shadow with colored pencils and, if
needed, pull out the white gouache to add
highlights. With the cookie I chose, the
highlights—those little white specks you
see—were pretty crucial. They took a draw-
ing that was "good enough" and elevated it
to a level of real three-dimensionality. Not
every illustration requires white gouache
highlights, but the ones that do tend to be
uniquely pleasing to the human eye.

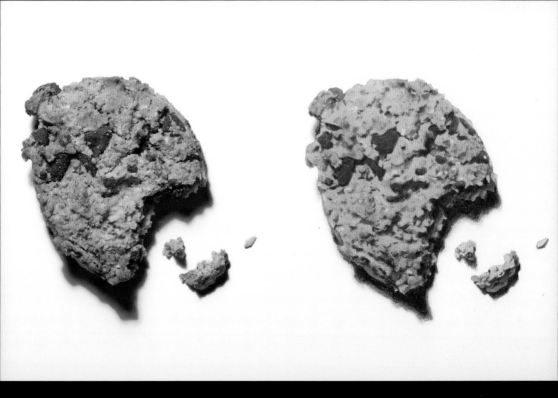

THE FINISHED PIECE Take a moment to reexamine all the various facets of your illustration, just in case anything needs tweaking. Once you've completed this last bit of polish, you're done. Go ahead and eat that cookie: you've earned it!

Leaf

In the preceding lessons, I avoided using brightly colored items so that I could focus on lights and darks and other basic aspects of rendering objects on the page. Now you're ready to go beyond muted browns and tasteful grays and to plunge headlong into the blazing reds and yellows of an ordinary autumn leaf.

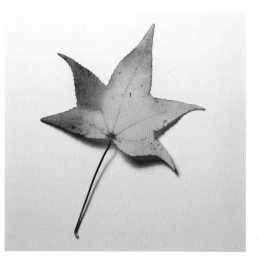

1 Draw the contours of the leaf in pencil. I selected a leaf with minimal details in terms of its structural "veins." You may want to consider doing the same. Rendering a full-color leaf is tricky enough, without also having to labor over highly complex surface details. Pay attention to the jagged edges of the leaf: getting this aspect right is key to recreating a leaf properly.

2 Observe what color dominates the leaf you've chosen. In my case, it's yellow, so I prepared the appropriate shade of yellow with my watercolor paint. Rather than attempt a gradual change of color from red to yellow, I decided to keep things simple. It's all yellow at this stage. I applied the color a bit more lightly on the left-hand side of the leaf, knowing that this area's color will change the most in subsequent steps.

3 Switching to colored pencils, begin gradually building up a secondary layer of color. The color may be quite smooth in some areas and a bit more uneven in others. No need to go for a finished level of surface detail now: that can wait. For now, it's enough to just get started.

4 Continuing with the colored pencils, work your way around the entire surface of the leaf, adding bits of detail here and there. My approach is to save the darkest bits for last, so it's all still light tones and midtones at this stage. The leaf I chose had a number of brownish imperfections on its right-hand side, so I went ahead and altered my illustration accordingly.

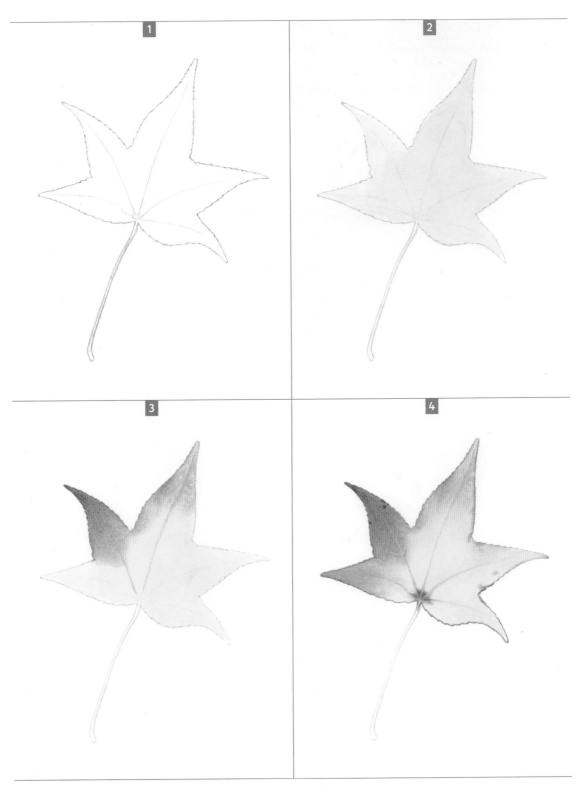

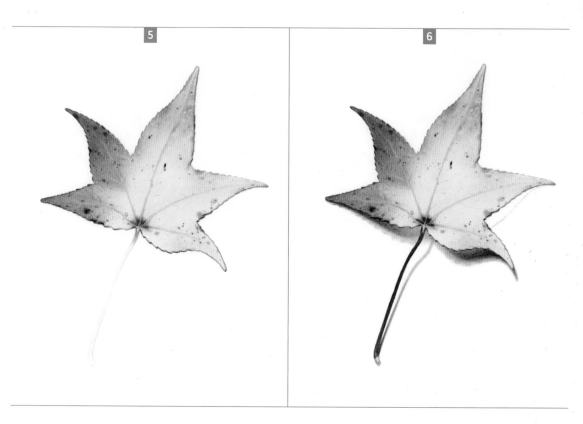

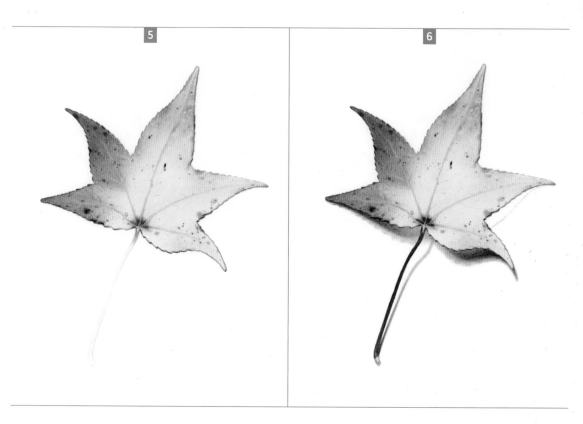

5 Now you can challenge yourself to really go for it all with the details. Part of the key to pulling off a realism challenge is getting all those details in just the right location. You can apply such details with watercolor if you like. I chose to stick with colored pencils just to keep things simple.

6 If you have held off on doing the stem as I did, now's the time to get to it. I felt I needed to use bold, solid color in this area, so I switched to watercolor. It required patience and was even a bit nerve-racking, I must confess. Getting a watercolor brush to stay within such a narrow space is a tall order! For the drop shadow, you may find that it is rather more complex than a simple area of black. It will generally be darker in the areas where the leaf touches the paper, and lighter where it doesn't. Capturing these variations of light and dark is the final key to pulling off this challenge.

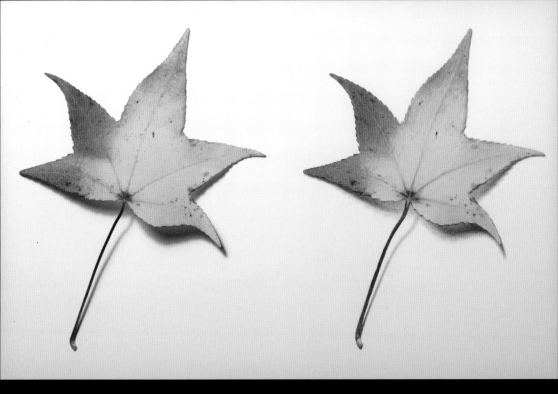

THE FINISHED PIECE And there you have it: the beauty of autumn captured in a single leaf. If you're pleased with the results, why not try a leaf of a different color? The more of them you do, the better you'll get.

Toast with Jam

Consider yourself warned: after this lesson you will never look at a slice of toast the same way again. Toast puts the *challenge* in realism challenge to a degree beyond anything you've taken on so far. The good news is that completing this one will prove excellent preparation for the more visually impressive challenges to come.

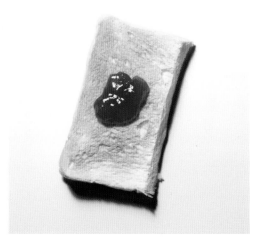

1 Begin by penciling the outline of the toast as well as the more prominent "craters" on its surface. If you have chosen to add a dollop of jam as I did, go ahead and draw the contour of that as well.

2 Now add a layer of watercolor that matches the basic color of the toast as best you can. You're covering a relatively large surface here. That means you need to use a large brush, and to make sure your color has plenty of water in it, so that you're not struggling to have it cover the whole area from one side to the other.

3 Here comes the biggest test of your patience so far. Take your colored pencils and begin rendering the textured surface of the toast. There are hundreds of tiny indentations. While you don't need to obsess over every one of them, you can't get away with just slapping down a bunch of dots either. Do your best to place the more prominent markings where they belong. Note that I have used gray watercolor to add shadows to the "craters" I drew in step 1.

4 Once you've completed the toast's surface texture—and believe me, that process can easily take an hour or two—it's time to add the jam color. What you see here is actually two layers: a pale pinkish layer that remains partially visible along the edges, and a second layer that is more of a solid red. You'll want to allow the first layer to dry completely before you add the second.

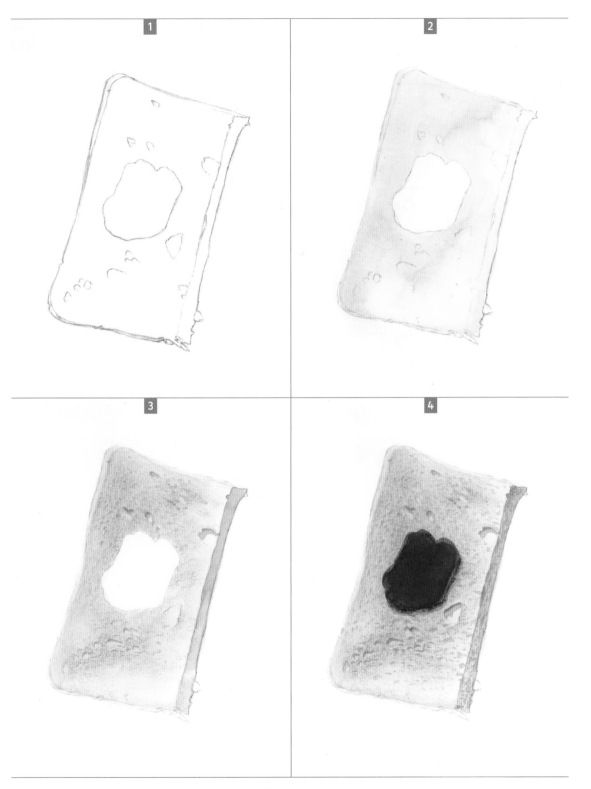

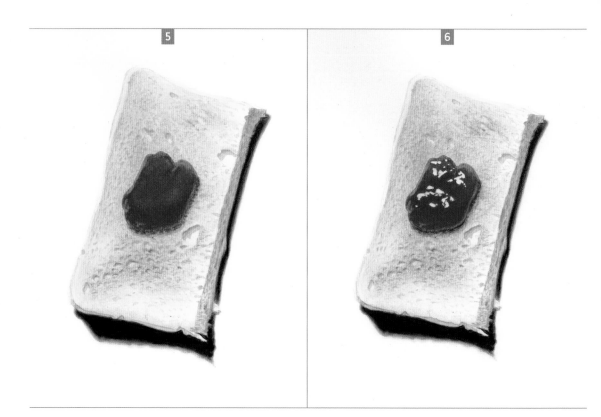

5 You're almost done. Using colored pencils, add the drop shadow and a bit of shading to the jam. In my case, the lighting was quite stark, resulting in a jet black drop shadow. You may have a different lighting situation—for example, more of a pale gray may be needed—in which case you'll need to choose the proper colored pencils to reflect that situation.

6 With this lesson, you can see the power of white gouache highlights taken to a new level. Unlike watercolor, you want white gouache to be quite thick, so that it fully blocks out the color underneath it. I'm always surprised how effective the "shiny wet" illusion is, even when the gouache has been applied with minimal skill. There's something about the high contrast of the white against a darker color that fools the human eye every time.

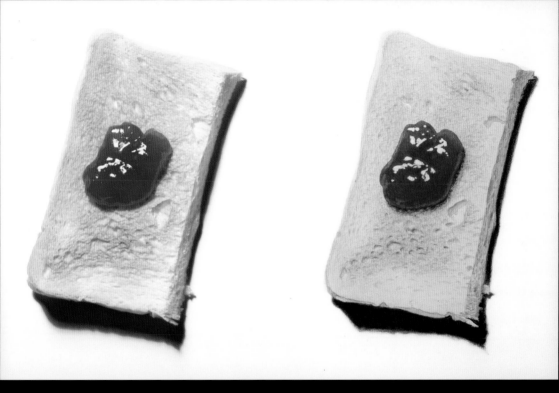

THE FINISHED PIECE Hats off to you if you made it this far. And if you have, I'm sure you'll agree I wasn't exaggerating about how hard it is to illustrate a slice of toast. Just between you and me, that might have had something to do with my decision to slice it in half at the outset: I didn't want to deal with any more of that toasted brown surface than was absolutely necessary!

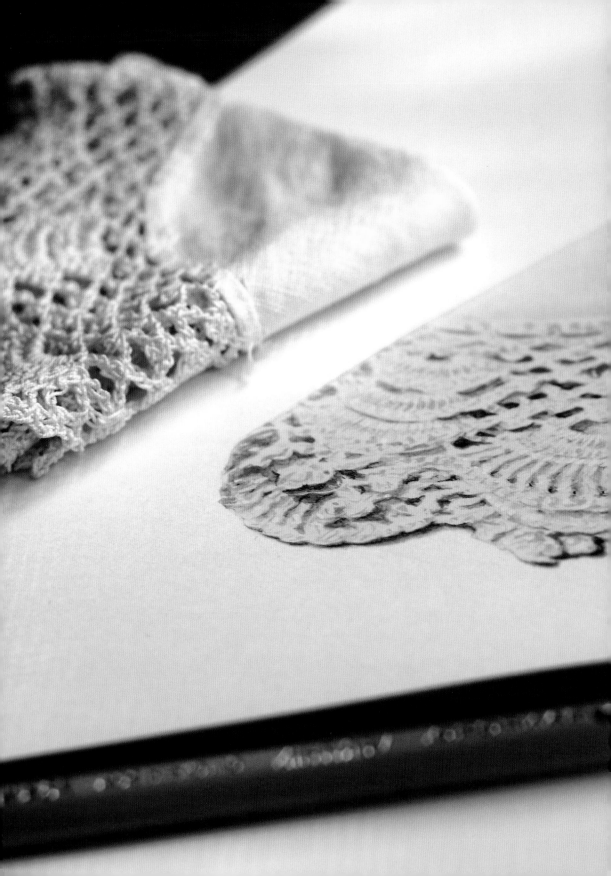

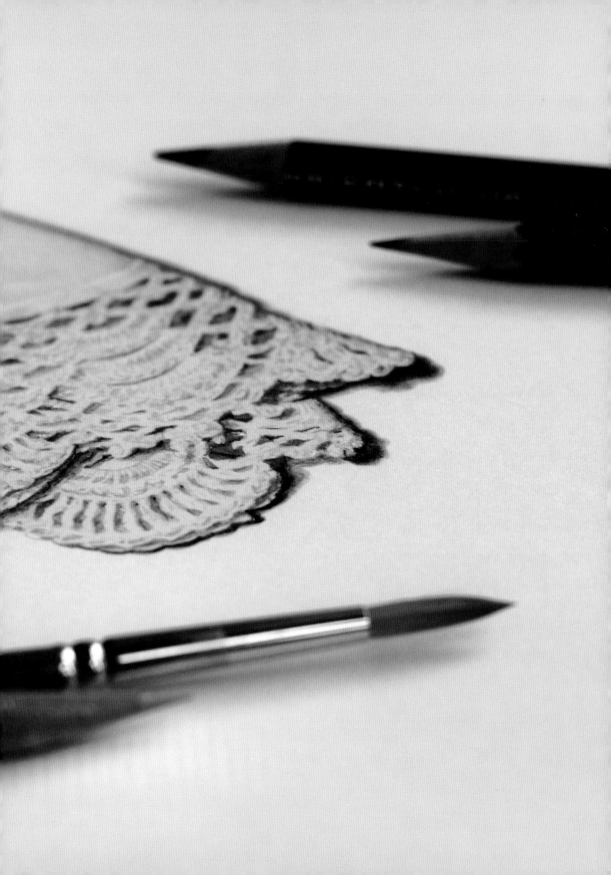

Advanced Surfaces

Now that you've taken on a few full-color items, you're ready to move on to objects with unusual surfaces. Part of the joy of working on a realism challenge illustration is watching as your blank sheet of Bristol begins to emulate the exteriors of decidedly unpaper-like objects. In this chapter, you'll learn how the right combination of watercolors and colored pencils can re-create surfaces as diverse as wood, lace, or porcelain.

Porcelain Plate

When it comes to selecting objects for
a realism challenge, those with shiny
surfaces always steal the show. Something
about the little glints of light that flash off
these objects is particularly dazzling when
captured in an illustration. As with the
dollop of jam in the previous lesson, white
gouache is the art supply that does the
heavy lifting here. The shard of a broken
porcelain plate can help you continue your
progress toward mastering its use.

1 The first step is to get the outline and
basic details down in pencil. Some
embossed patterns are so detailed that they
almost seem beyond rendering by human
hand. In truth, you can be a bit impression-
istic with such details: the final effect will
not hinge on your outlining every leaf and
ornamental border flawlessly.

2 Next, add a very pale shade of beige in
watercolor. It may not look like much,
but this base layer will prove crucial later
on. It allows the white highlights to "pop"
off the page in a way they never would
without it.

3 Here I switched to a light gray colored
pencil to begin rendering the shadows
of the embossed patterns. If you've paid
attention to your light source, you should
be able to predict where the shadows will
fall. For me, the light came from the upper
left, so all the shadows occurred on the
lower right-hand side of each element in
the design.

4 Continue until you've placed all
the shadows: not just those of the
embossed pattern but also those along the
edge of the plate itself. I found that a com-
bination of light gray and dark gray colored
pencil was needed to convey the subtle
range of value in these various shaded areas.
Indeed, subtlety is the name of the game
with this lesson. There are no bright colors
or shocking contrasts.

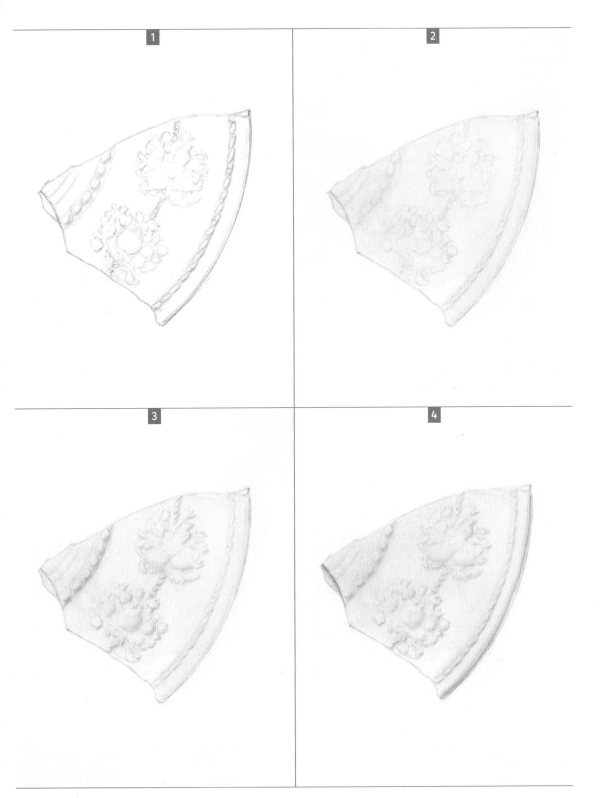

5 At last, it's time to bring out the white gouache and let it perform its magic. Taking care to observe every glint of light found on the surface of the plate, dip your smaller brush into the white gouache and carefully apply dabs of it in the corresponding spots on your illustration. Opacity is essential. If there is too much water in your gouache, it will be translucent, vanishing into the beige watercolor behind it.

6 Of course, you're not done until you get the drop shadow in there. Caution is needed at this stage. Even after it has dried, the gouache won't remain pristine white if you allow your hand to rest on it. (And pristine white is what you really need.) So take care to apply the drop shadow without touching the gouache at all.

THE FINISHED PIECE There you have it: the quiet little miracle of white gouache highlights! In the lessons ahead, you will find yourself using this technique again and again, often with dramatic results indeed.

Wooden Carving

I've always loved the look of dark wood, especially when it's old and weathered. So imagine my pleasure when I came across this carved cherub's head in an antique store. I knew it was the very thing I needed for this book. By creating a faithful reproduction of it, I can teach you a lot about the illustration techniques needed for depicting wooden surfaces.

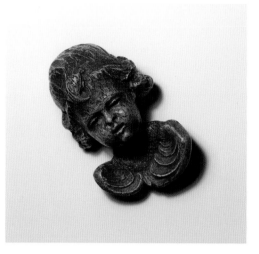

1 This time the penciling stage is a bit more involved than in past lessons. I had to get the facial features copied accurately—never an easy task, no matter how many years you've been drawing. In any case, this part of the process involves drawing not just the object itself but also some of the wood grain you see upon its surface.

2 Switching to watercolor, you'll need to mix up a base color that matches the selected wooden object. I haven't attempted anything in the way of detail at this point. A hint of shading in the hair and some of the contrast at the chin were all I needed at the outset.

3 Continuing with watercolor, it's time to move gradually toward greater detail. In my case, this meant rendering the eyes, some of the hair, and the curving lines of ornamentation beneath the shoulders. I'm not leaping straight to the obsessive nit-picky stuff. For now, it's all about getting the most important areas of darkness in place.

4 Now it's time to bring out the colored pencils. I primarily used a single shade of dark brown at this stage. With some objects, you struggle to conceal the natural graininess of colored pencil. Not so with wood. The slightly rough look is just what I needed. Only in the areas of the eyes, mouth, and a few bits of the hair did I press down hard on the colored pencil to go for a pure dark brown.

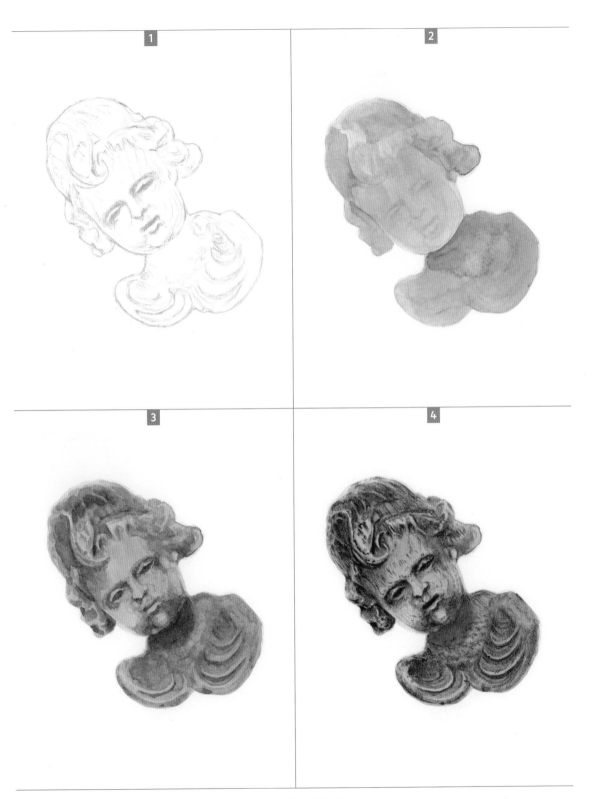

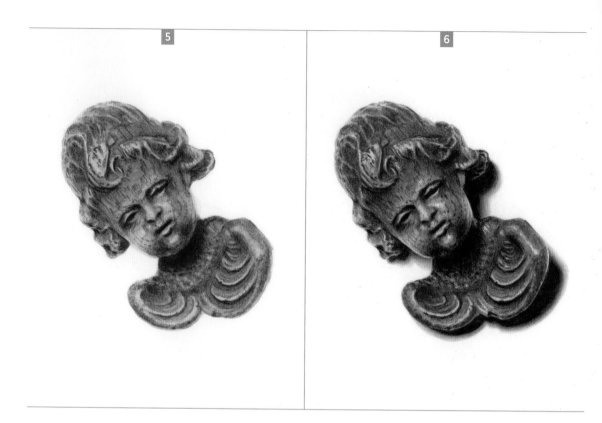

5 Let's start to get into some of that "obsessive nitpicky stuff" I was talking about in step 3. The brown colored pencil does the lion's share of the work here, but dabs of brown watercolor also play an important part. It is the two media together that allow you to convey the full complexity of a wooden surface. I constantly traded back and forth between the two as I neared completion.

6 It's time to add the drop shadows in colored pencil and the highlights in white gouache. A weathered piece of wood has an interesting sort of semigloss finish to it that calls for highlights that are numerous yet judiciously applied. You don't want them to be too large or too bold. But dropped in at just the right amount, these highlights will cast a spell of three-dimensionality on your illustration that makes all the difference in the end.

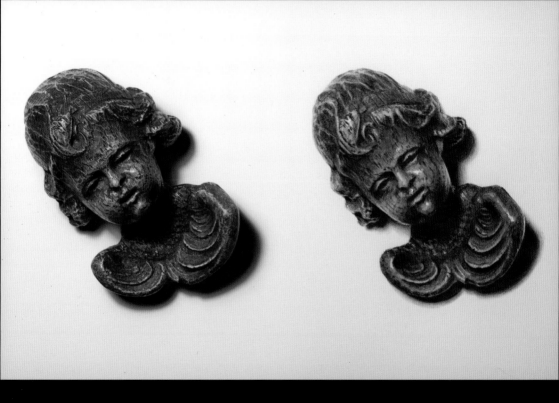

THE FINISHED PIECE I found that this small wooden sculpture, though not without its problematic elements, was particularly well suited for the "realism challenge" treatment. You could almost say that the rougher and more imperfect a surface is, the more success-

Cut Rose

For centuries, artists have taken part in the tradition of painting flowers. And no wonder: there are few things on earth so pleasing to the eye. Completing this realism challenge of a cut rose will not only be great exercise for you as an artist, it may well result in an illustration you'll want to frame and hang on your wall.

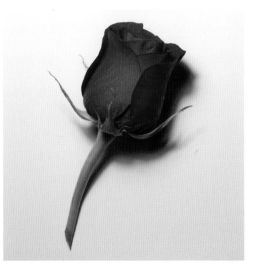

1 Begin as always with a careful pencil drawing of the target object. For my flower, I chose a red rose, not yet in full bloom. Different flowers will, of course, present different challenges to the artist. For example, an orchid will demand a more complex pencil drawing at the outset, and will likely prove more difficult throughout the entire illustrating process.

2 Next, apply a base layer of watercolor. The bold colors of the rose resulted in somewhat darker colors than I used at a similar stage in most of the previous lessons. When you know you're heading toward a darker final color, you can commit to a more substantial shade at the outset.

3 Switching to colored pencils, begin adding color, shadows, and other details to the petals. I chose to use a petal–by–petal approach, bringing each small area to completion and gradually working my way down from top to bottom.

4 Continue until you have captured all the remaining details of the flower with your colored pencils. I found that the combination of watercolor and colored pencil was particularly well suited to representing the silky texture of rose petals. Note the importance of retaining the minor imperfections of the petals in the illustration. Don't try to improve on nature by "editing out" any little irregularities. They are the very things that trick the human eye into seeing your picture as a real rose.

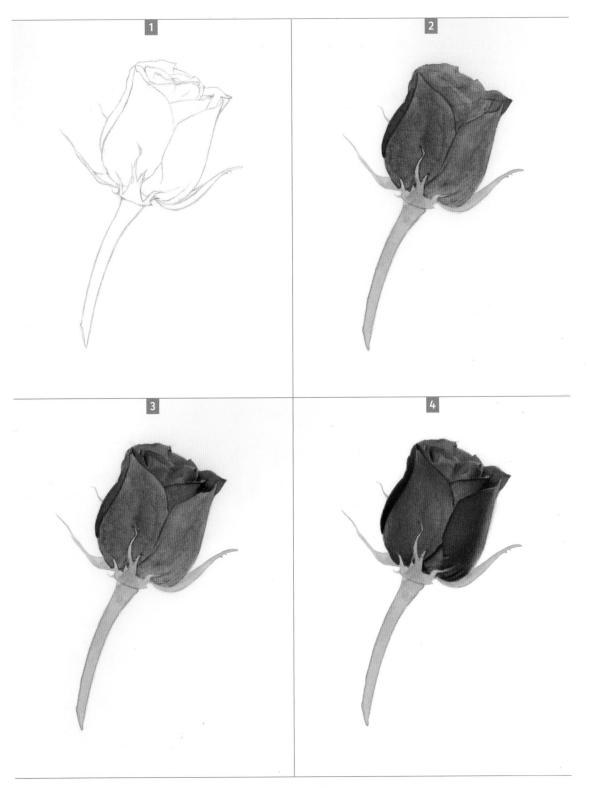

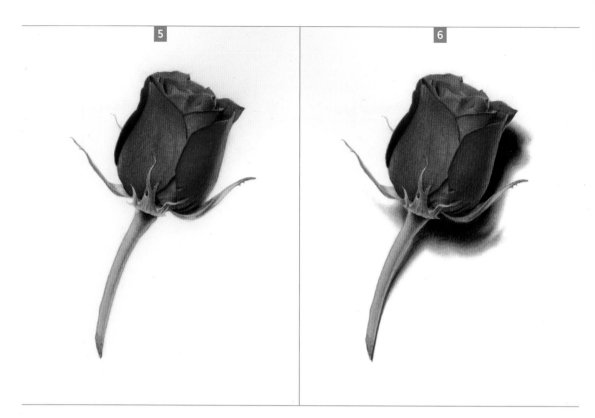

5 Turn your attention to the stem. I found a second layer of watercolor was needed to bring the green hue to where it should be. The remaining details are all done with colored pencils. Be careful to give the stem as much care and attention as you gave the petals. This area of the illustration is every bit as important for conveying a sense of three-dimensionality.

6 Last comes the drop shadow. This rose has a good bit more mass to it than many of the objects featured in previous lessons. As a result, the drop shadow is larger and less crisp here. In such situations, the gray colored pencil is an important tool: it allows you to capture the gradual transition from dark to light at the shadow's edge.

THE FINISHED PIECE There's no denying the loveliness of a carefully executed floral illustration. Next time you have cut flowers in your home, why not clip one and give it the realism challenge treatment?

Drop Shadows

Let's face it: drop shadows don't get a whole lot of respect. The object being illustrated— whether it's a pretty flower or a straight-up piece of junk—gets all the attention. But in many cases, it is the drop shadow that must be credited as Most Valuable Player in the drawing. Remove the drop shadows from any of the illustrations in this book and the illusion of three-dimensionality is utterly lost. So take your time with rendering them. The edge of the shadow, where it may change gradually from black to gray, is worthy of extra attention. Also be sure to double-check the rest of the drawing once you've added the drop shadow. You may need to darken things up a bit in the object itself so as to make it match the shadow in intensity.

Folded Lace

When it comes to realism challenges, you can't accuse me of taking the easy way out. I could have saved myself a lot of time by choosing a simple white handkerchief for this lesson, but where would be the fun in that? Sure, a lace doily by its very nature is maddeningly difficult to illustrate. But it is precisely these sorts of objects that give you a greater sense of artistic achievement when you take them on and refuse to let them defeat you.

1 This is almost certainly the hardest of all initial pencil drawings so far. You can make things a little easier on yourself by choosing cloth with less intricate lace, or by folding it in such a way that less of the lace is visible. Measuring the target object with a ruler will help make your pencil drawing more accurate. Take your time. This lesson is an endurance test of sorts, and it's definitely a matter of "slow and steady" winning the race.

2 Happily, this next step is much simpler. Use your eraser to lighten up the lines of your initial drawing, and then cover the entire area with a base layer of watercolor. My doily had a yellowish tint to it, so that's the kind of color I needed to use. If your target object is bright white, you may be able to get away with the easiest job of all: skipping the second part of this step and moving on to the next one!

3 Staying with watercolor, mix up a slightly darker shade and begin painting in the little gaps in the lace's design. This is definitely one for the fine-tipped brush. Watercolor has a nice way of drying so that the outer edges of each dab of paint ends up slightly darker than the interior. This natural tendency works in your favor when illustrating lace: each gap in the design becomes crisp and clean, almost as if you'd gone back in to carefully outline each of them.

4 Set the brush aside and pull out the colored pencils—tightening things up further. I found a shade of gray that was ideal for adding details to the interlocking components of the lace. You're at the level of individual threads here: outlining every one of them would require a superhuman level of patience. I chose instead a more impressionistic approach, allowing my pencil strokes to suggest the presence of tiny loops of thread within the design.

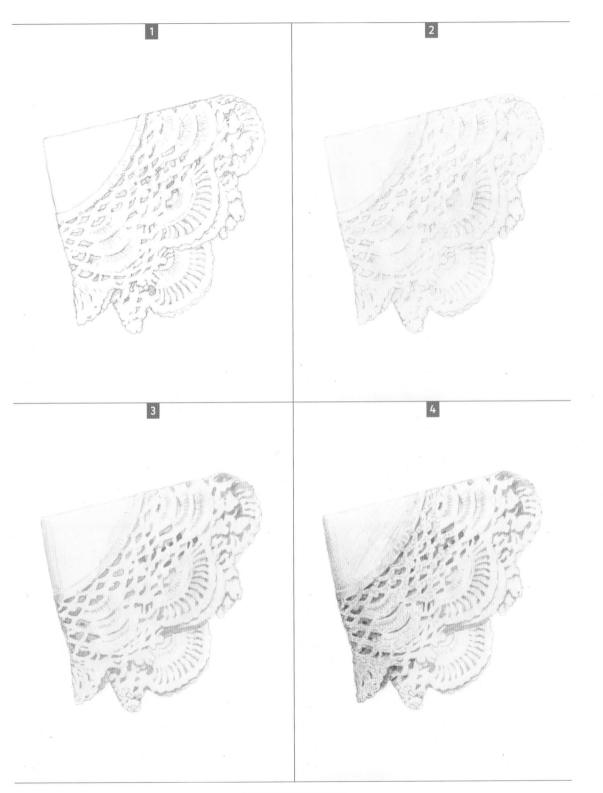

1

2

3

4

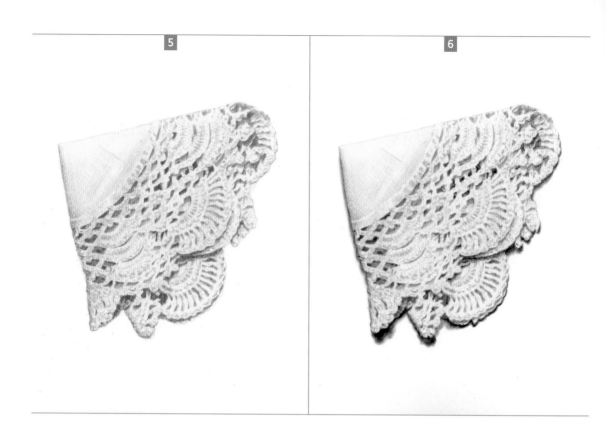

5 At this point, I traded back and forth between watercolor and colored pencil, allowing each to do what it does best. The watercolors excelled at indicating pockets of shadow, while the pencils were better for adding texture throughout the illustration. Note that the shaded areas are not uniform blocks of color. You are often able to see even darker areas within them that draw your eye deeper into the design.

6 Complete the illustration by adding the drop shadow with colored pencil. Much like the crumpled piece of paper on pages 14–17, this folded lace doily is low to the ground and casts only a very small shadow. Nevertheless there is variety within that narrow sliver of shade, ranging from jet black to light gray.

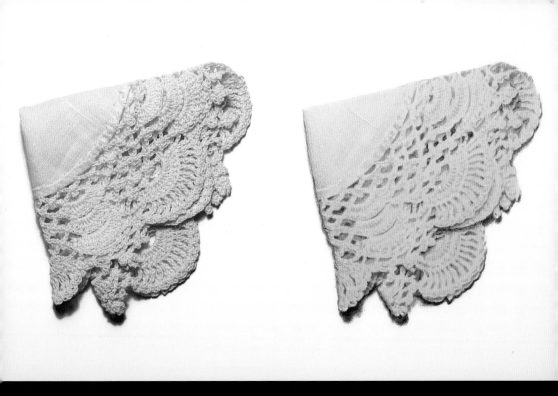

THE FINISHED PIECE Finished at last! In all honesty, I can tell you this realism challenge really pushed me to the limits of my abilities. Something about lace makes it particularly hard to replicate, even beyond the intricacies of its patterns. So hats off to you if you choose to give it a try. It is excellent training for any artist, both in terms of the skills it

Strawberries

By now, you've drawn popcorn, a mushroom, a cookie, and a slice of toast with jam. You may be asking yourself, *Was Mark hungry when he made this book?* In my defense, items of food do tend to have interesting surface textures, and that is one of the key elements for a realism challenge. Case in point: these strawberries, with their shiny red exteriors, practically cry out to be replicated in watercolor and gouache.

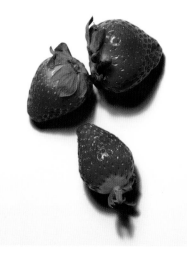

1 Draw the contours and surface details of the strawberries in pencil. The leafy bits aren't easy, but the seeds are the real challenge. The idea of counting them and drawing each and every one may seem more than you can deal with. Indeed, I fear I missed a few of them here. Happily, the human eye is pretty forgiving. In the end, as long as you manage to get close to the right number of them, in close to the right places, you'll be okay.

2 As was the case with the rose on pages 66–69, you know you're heading toward bright colors with this one. So pull out your watercolors and mix up fairly bold shades of red and green. The tricky part here is the area where the red fades to white near the top of each strawberry. This feature requires you to keep the paper quite wet and make sure the dividing line between the two colors remains a bit blurry as it dries. Have a tissue handy to dab away any excess red paint.

3 Relying on your fine-tipped brush, add detail and shading to the leafy crowns of each strawberry. This is primarily done with additional layers of green paint, though I noticed the color was a bit brown in one place and did my best to capture that. As always, little details like this can make a surprisingly big difference. Notice also that I took a moment to add more definition to the seeds with my my graphite pencil, knowing that I'd need to focus on them in subsequent steps.

4 Switching to colored pencil, begin adding color and shading to both the leaves and the strawberries. I found that light reflected off the paper and partially illuminated each strawberry, even in areas covered in shade. This meant I had to allow the first layer of red watercolor to remain largely untouched in those areas. If colored pencil doesn't give you the full depth of color needed, feel free to go back in with watercolor. Often it is the combination of the two that really delivers results.

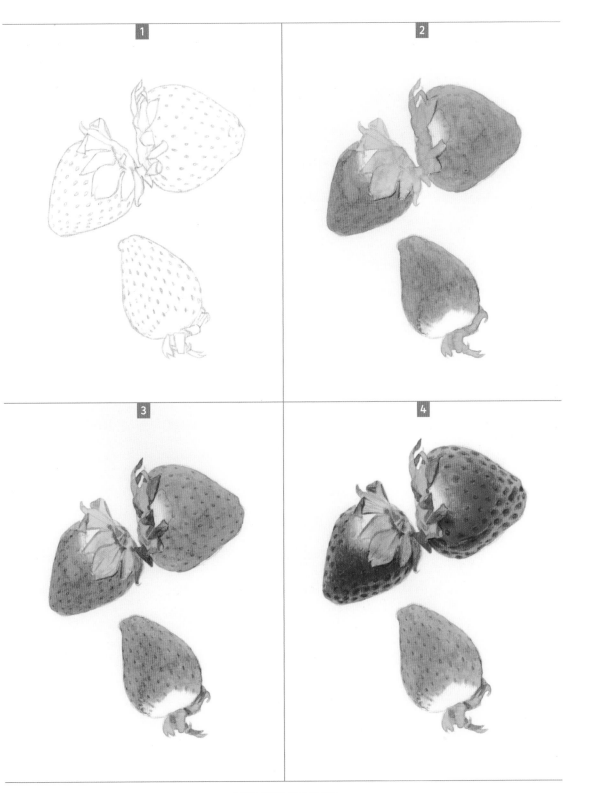

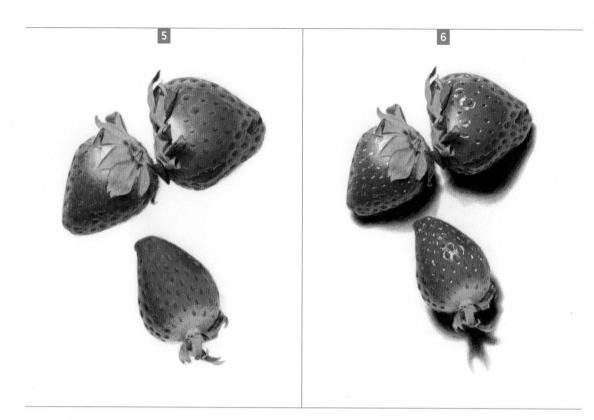

5 Alternating between colored pencil and watercolor, continue adding detail and shading throughout. I made the somewhat unusual choice of using a light gray colored pencil to represent the reflected light around the edges of the strawberries. But this is the color I saw when I looked at those places on the target objects. Sometimes you have to tell your brain to stop questioning the logic of adding gray to a red strawberry. Let your *eyes* have the final say. If that's what you see, that's what you put in the final illustration.

6 Add the drop shadows in colored pencil and the highlights with white gouache. Remember what I said about shiny surfaces always stealing the show? These strawberries are an excellent example of that. A few strokes of white paint, and suddenly it looks like you could reach out and grab the strawberries off the page. To take it a step further, I mixed yellow watercolor with white gouache to paint the seeds on two of the strawberries.

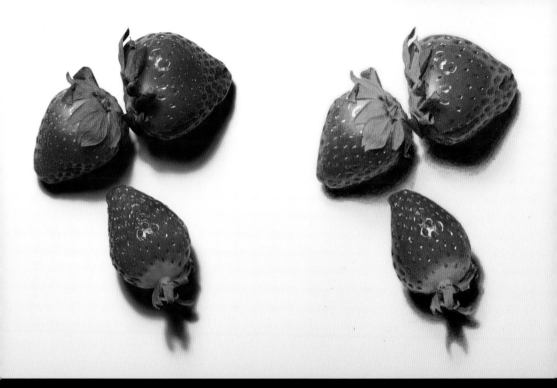

THE FINISHED PIECE So now you know the secret: the ideal candidates for a good realism challenge have been sitting there waiting for you every day at the grocery store. As to whether or not I was hungry while working on this book, well... no comment!

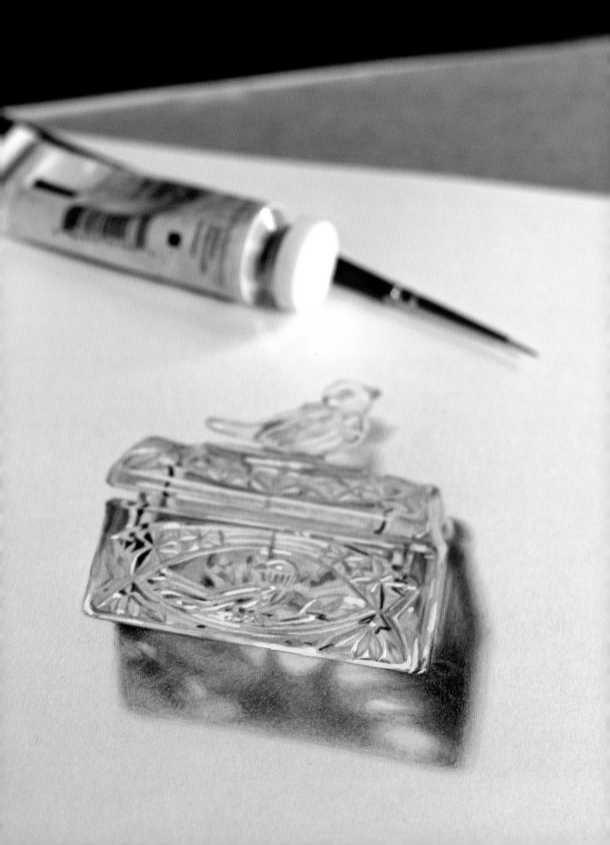

Transparent Objects

Now that you've tested your skills illustrating a variety of surfaces, it's time to move on to items that present special challenges. Transparent objects create a unique experience for the human eye. Though we encounter such items every day, it is always a bit novel to see through something all the way to its other side. As a result, illustrations of such objects invariably take on a visual appeal that sets them apart.

Small Bottle

Depicting a transparent object in illustrated form presents an obstacle to the artist. How can you represent the surface of a piece of glass when its surface is something you can look straight through? It becomes a matter of focusing on the unusual shadows cast by the object and the subtle gradations of color throughout the illustration. Often you find yourself shifting from one shade of gray to another one that is just a fraction lighter or darker.

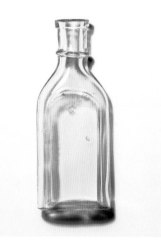

1 Draw the most important lines of the bottle in pencil. I rendered a few of the areas that represented reflected light, but mainly I concerned myself with lines directly related to the bottle's structure. Less is certainly more at this stage. If you put down too many lines, you'll just have to go back and erase them later on, since there are relatively few bold lines visible in the target object.

2 Lighten all the lines with a kneaded eraser. Then mix a shade of very pale gray in watercolor and cover the entire surface of the bottle from one contour line to the other. Once that has dried, go back in and add some of the areas that are slightly darker. Watercolor tends to dry with a hard edge to it, so you may need to have a tissue handy for dabbing color away in areas where you need a blurred effect.

3 Now that you have a good base color in place, you can begin to refine things a bit with gray colored pencil. Of course, glass tends to be supersmooth and essentially textureless. This means your pencil shading must be very carefully built up so as not to reveal the individual strokes that make it up.

4 Continue with colored pencil until you've added all the shading needed from top to bottom. Glass bottles often have an interesting area of refracted light at their bottoms where the glass has added thickness. Here you may need a darker shade of gray to capture the full range of values. As always, it is the target object that guides you through the process: anything you see in the bottle, you must add to your illustration.

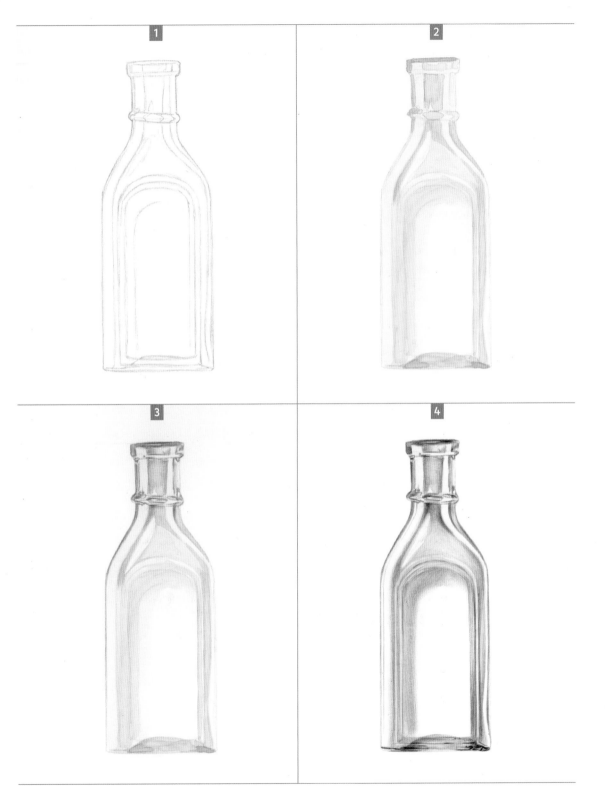

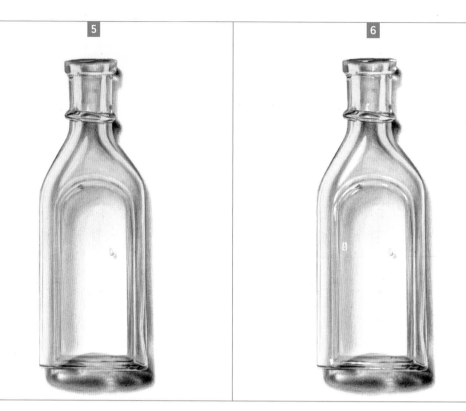

5 Up until now, rendering the drop shadow has been a pretty straightforward affair. But once the item casting it is made of glass, the shadow is transformed into something at once more complex and beautiful—a lovely little mix of lights and darks stretching across the page at unpredictable intervals. Black and gray colored pencils can capture the effect, given patience and careful attention to where one color shifts to another. My bottle had a few brownish imperfections as well as a tiny bubble caught in the glass, so I took a moment to add them with colored pencil.

6 White gouache highlights can add a nice final touch for many realism challenges, but with those involving glass the highlights take on added importance. It is that tiny glint of light off the surface that really defines an object as being made of glass. The difference between the pictures in steps 5 and 6 may seem minor, but it is actually a decisive part of the final effect.

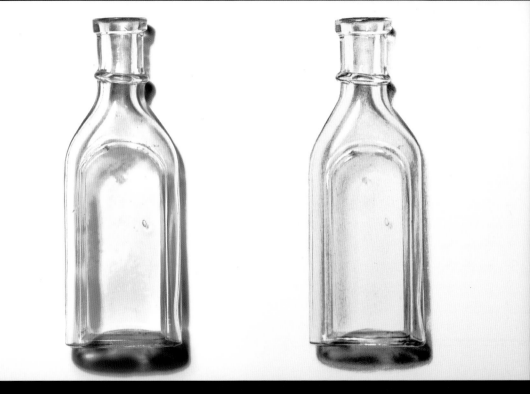

THE FINISHED PIECE I find the challenge of illustrating glass particularly fascinating.
That's why I decided to devote a whole chapter to such items. Though these lessons may
require a little more patience than some of the others, you will be rewarded with a great

Glass Box

Contrast is at the heart of the most impressive realism challenges. Something in the sharp juxtaposition of darks and lights dazzles the human eye, and the person viewing your illustration becomes a willing accomplice in the trick: "It looks so real!" So it is that a decorative glass box becomes one of the most interesting subjects thus far. The cascade of lights and darks created by its multifaceted surface guarantees a spectacular final result for anyone who succeeds in capturing it on paper.

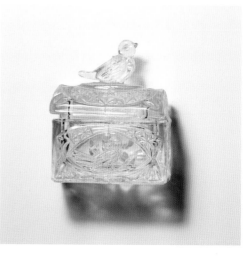

1 Draw the contour of the target object and all its most important details in pencil. Of course, your decorative glass item will likely be very different from mine. But many of the same principles will apply: you need to reproduce the item at its exact size in real life, and to provide guidelines for all the various spots where you will be applying blacks, whites, and grays later on.

2 To begin, I chose to mix up a shade of light gray watercolor and to cover the entire area with a single uniform layer. Even the clearest glass object will have some slight tint to it. Moreover, the highlights applied at the end of the illustration process can't "pop" if they have to stand out against the white of the page. They need at least the contrast of a pale gray behind them.

3 Starting now, it's a matter of combining both colored pencil and watercolor to record all the variations of gray and black in the surface of the glass. You will need your best powers of observation to see where the different shades belong. Take your time and have a little faith in the eventual outcome. I often have my doubts in these early stages when the effects I'm aiming for have not yet been achieved: *It's not looking very glassy. Will I be able to pull this off?* Well, there's only one way to find out, and that's to keep working at it, little by little.

4 Continue the process until you have added all the various tiny gray shapes seen in the target object. Remember to let your eyes be the boss and to ignore any preconceptions of what you think it "should" look like. For example, my glass box had the image of a bird etched into its side, and it was tempting to try to make that bird shape clear in the artwork. But that wouldn't have been true to what lay there before my eyes. The glass-etched bird was pretty hard to see, and so it needed to be hard to see in my illustration.

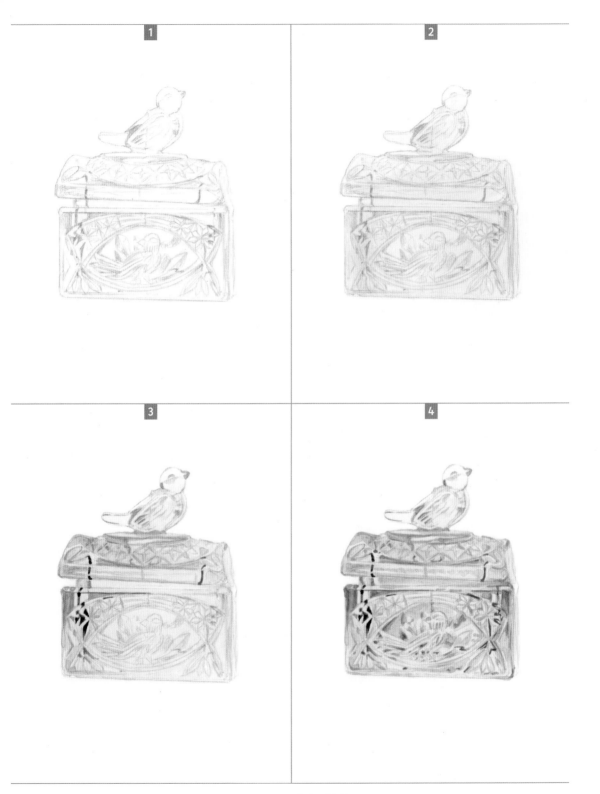

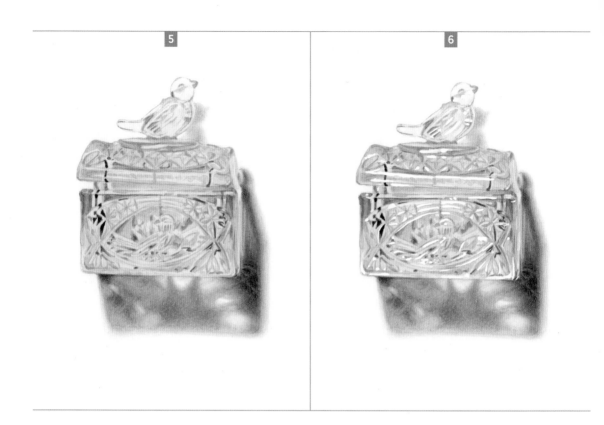

5 Once the target object is complete, you can turn your attention to the drop shadow. A blurry buildup of colored pencil is always my preferred approach for this part of the process, since watercolor tends toward a crisp edge. The faceted surface of the glass resulted in an attractive arrangement of grays and whites within the drop shadow area, so I was careful to take my time and capture all these various areas, one at a time.

6 If you've invested the energy needed to get to this last step, you will be pleased to know the hard part is over. Now is the time that white gouache swoops in and produces a difficult-looking effect that's all out of proportion to how easy it is to achieve. Yes, you need some skill in terms of brush control. But it can be surprising—even to the person doing the illustration—how vast the difference is between the "before" and "after" of the white gouache stage. The key is not to overdo it. Take care only to apply gouache in the spots where you see pure white glinting off the target object.

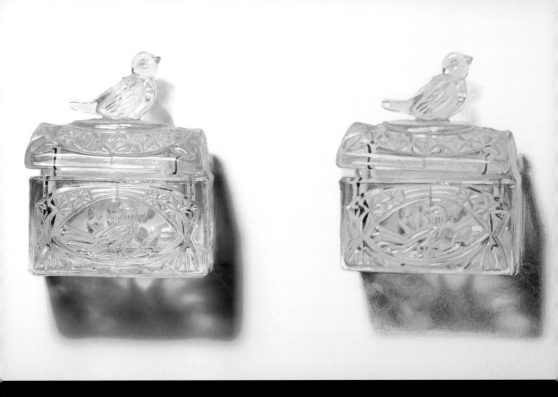

THE FINISHED PIECE Remember, there's no need to search all over town for a glass box that looks just like this one. The main thing is to find any glass item that has at least some variety in its surface. Regardless of shape or size, it's sure to create similarly striking contrasts once light passes through it and lands on the paper.

Marbles

Just because something is made of glass doesn't mean it can't be colorful. When I came upon these old-fashioned marbles at a toy store, I knew they'd make for an interesting realism challenge. The ones with bands of color within them especially caught my eye, as they contained both transparent and opaque material, something I'd never tried illustrating before. Once I got them home I realized—somewhat comically—that I couldn't get them to hold still for the illustration! I was able to solve the problem with an old bit of string.

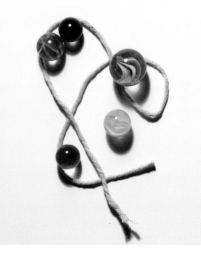

1 Happily, the process of drawing marbles in pencil is a comparatively simple one. Indeed, in my case, two of them were little more than a couple of circles. The string offers a bit more of a challenge, especially if you are determined to record its various angles accurately.

2 After dabbing away some of my pencil work with a kneaded eraser, I used watercolor to apply a base layer to everything in the illustration. Two of the marbles were so near to black in color that I felt confident about laying down a very dark gray. The largest of the marbles would eventually need some bright colors, but to begin with I decided to lay down a superlight gray in that area and leave it at that.

3 Working top to bottom, I used colored pencils and watercolor to add detail and shading to the upper three marbles and a section of the string. In this instance, the natural graininess of colored pencils was something of a drawback. Marbles have a glossy perfection to them that is slightly at odds with both watercolors and colored pencils. My solution was to blend the two together as carefully as I could, leaving as few traces of colored pencil roughness as possible.

4 Continuing in this manner, I finished coloring and shading the remaining marbles and the rest of the string. At this point, I took the unusual step of using watercolor to drop a bit of color into two of the drop shadows, one green and the other yellow. This was because I observed that those two marbles splashed a bit of color on the page as light passed through them. My strategy was to get the colors in first before adding the rest of the shadows on top.

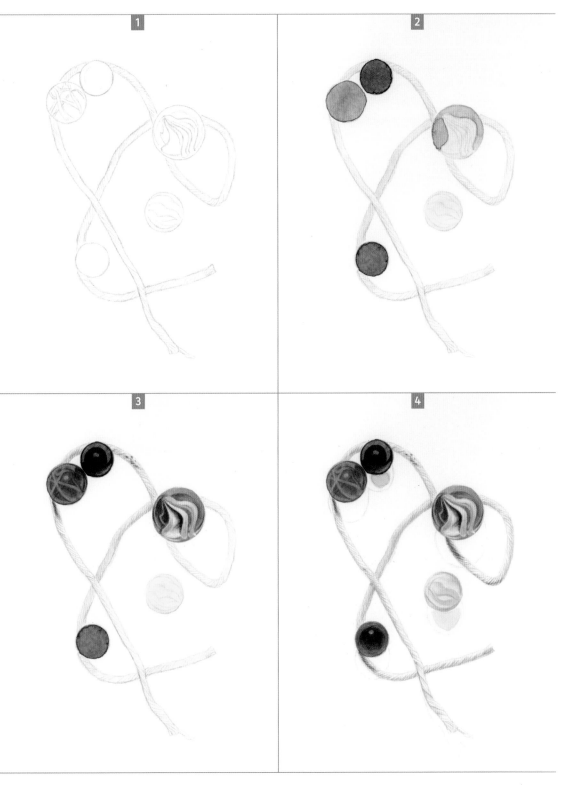

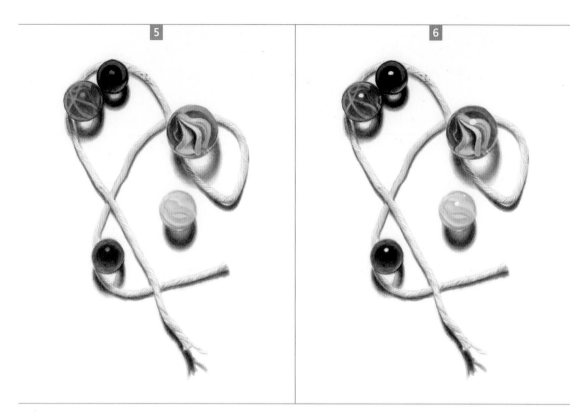

5 The drop shadows of marbles are beautiful in their own peculiar way. Each marble focuses light almost as a magnifying glass does, creating a little white dot in the center of its shadow (or a green or yellow dot, as the case may be). There is something a little otherworldly about these illuminated shadows, and I enjoyed the challenge of capturing their look.

6 The final touch was to add a single dot of white gouache to each marble. Of course, this is due to the presence of a single light source. If I had lit the marbles with two lamps, there would be two highlights per marble. As always, it's remarkable what a big role these little dabs of white gouache play in completing the glassy illusion.

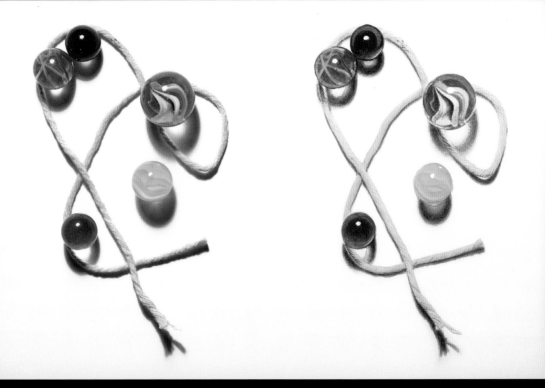

THE FINISHED PIECE In a way, I'm grateful that the marbles' tendency to roll around forced me to bring in the piece of string. The contrast between the two materials made this final illustration more interesting than it would have been had it featured only marbles. Next time you're at the toy store, keep your eyes open. You may find yourself picking up a bag of marbles and—like me—imagining the artistic possibilities.

Water Bottle

It's funny how doing an illustration of something opens your eyes to its details. On thousands of occasions, I've held a plastic bottle of water in my hand, but I never really took a good, long look at it. Not until I turned one into a realism challenge. The bottle you see here is quite an ordinary one, though certainly on the small side. Realism challenges must always be "actual size," and the larger the object you start with, the longer your illustration process will take.

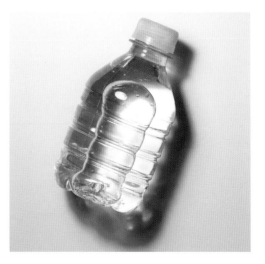

1 The first thing I did was tear off the paper label: I wanted this to be about the water, not about the company that had bottled it. This is certainly one challenge where a ruler comes in handy. Measure the bottle from top to bottom and side to side so that your pencil drawing is the exact same size. Then draw all the important structural lines in pencil. I found that a pocket of air formed between the water and the upper surface of the bottle, creating an interesting bulbous shape.

2 Mix up a shade of light gray watercolor and brush in a base layer wherever you see darkness in the target object. Bottles made of glass or plastic often create an unusual lighting situation in which they become darker on the side that faces toward the light source. Conversely, the side of the bottle furthest from the light may become brighter, almost as if it is grabbing hold of the light and gathering it in that area. As always, there is no need to attempt perfection at this stage. You're just making a base layer of color and leaving the details for later.

3 Sticking with watercolor, begin adding a darker layer of gray in which you refine things a bit more. Note how some of the edges are crisp and clean while others are blurred. The crisp lines occur naturally when watercolor is applied to dry paper. You achieve the blurring situation by using a clean brush to apply colorless water to the area you want to blur. I often keep a tissue handy at such times to dab away extra color and to make sure the edge remains blurred as it dries.

4 Now begin to tighten things up with a mix of light and dark gray colored pencils. As was the case with the marbles in the last challenge, this is a situation where a smooth tone—not a grainy one—is your goal. You can achieve this by pressing down firmly with the colored pencil as you shade, carefully building up the tone without allowing any tiny specks of Bristol board to show through.

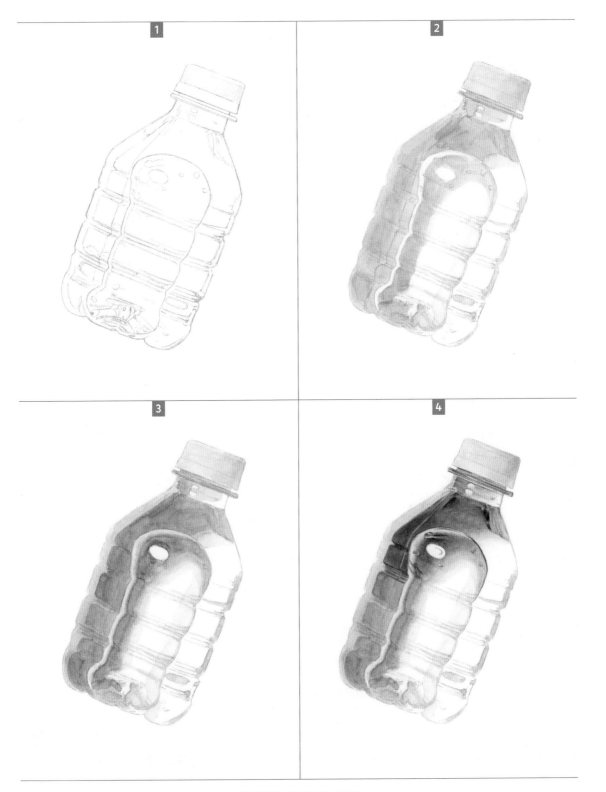

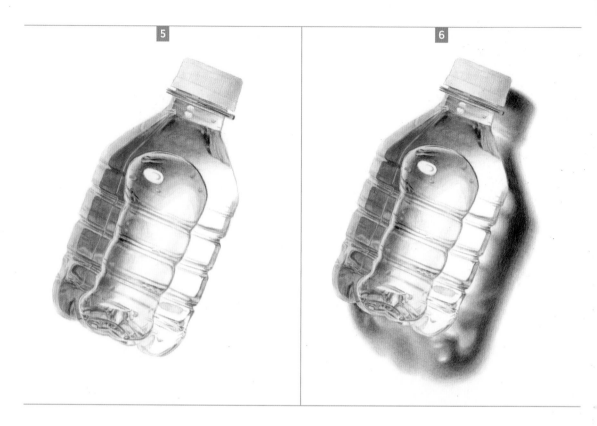

5 Continue with your gray colored
pencils until you've rendered all the
darker and lighter areas seen in the target
object. You'll need patience for any of the
lessons in this book, but you'll need it for
this one especially. I confess even I—after
years of training myself in this regard—was
tested by the sheer number of details in
this one. The bottom of the bottle alone
has dozens of tiny little areas, each need-
ing to be rendered accurately. Remember,
you don't need to do it all in one go. Take
breaks. Complete it over a period of days,
if necessary.

6 Next comes the drop shadow. As with
most of these "glassy" tutorials, the
shadow is partially illuminated by light filter-
ing through the bottle. In this way, the drop
shadow becomes even more important, in
terms of conveying three-dimensionality in
the illustration. Get all those little white bits
in there properly and the viewer's eye will
be really and truly fooled.

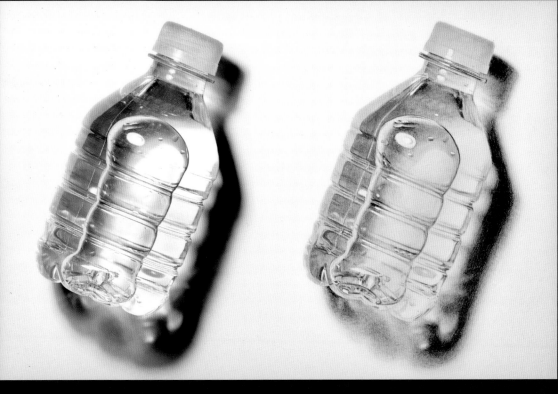

THE FINISHED PIECE Add white gouache highlights to complete the illusion. Take it from me: once you've completed a realism challenge like this one, you will never look at a plastic bottle of water the same way again.

Gradient Blends

As an artist, you sometimes find that the simpler something is in appearance, the harder it is to replicate in your illustration. Details can help conceal the imperfection of your individual marks upon the page. When you render an expanse of pure color, however, your shading technique is on full display. So, when you need to re-create a gradual change of color—from dark gray to a lighter shade of gray, for example—you must really up your game as an artist. I find that making tiny overlapping circular motions with the pencil is a good way to gradually build up tone. You may want to switch between two or even three different shades of the same color: dark gray, medium gray, and light gray, for example. Whatever you do, don't rush the process. Creating a good, smooth gradient blend takes time. The slower you go, the better your final result is likely to be.

Glass Arrangement

As I said in the introduction, a realism challenge is similar to the grand old tradition of trompe l'oeil painting, in which artists attempted to render objects so realistic looking that the viewers might think they could reach out and pull them from the canvas. One way in which you can make your realism challenge seem more like the trompe l'oeil paintings you see in museums is to illustrate not just one object, but instead a full assortment of them.

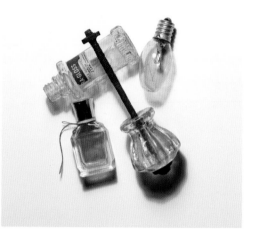

1 I began with four glass objects arranged in a way I found pleasing to my eye. Then I penciled in the contours and key surface details of each object. If hunting around in your own home doesn't turn up the kind of items that interest you, do what I do: head out to your local antique store. That's where I found many of the more interesting objects you see in this book.

2 I then used fairly pale shades of watercolor to create a base layer for the piece. I decided to go ahead and take care of some of the details, getting a start on the label's lettering and the metallic part of the light bulb. I had to take care in mixing watercolor for the perfume bottle's contents: even at this early stage, the more I could match the color of that liquid, the better.

3 Here I used additional layers of watercolor to refine the two bottles on the left-hand side. In a way, the bits of brown gunk on the top bottle actually helped me a lot as I moved forward. Including these little imperfections allowed me to show that this was a specific bottle in the real world. Authentic details like this are all but impossible to come up with when you try to paint a "hypothetical" bottle based on your memories.

4 Continuing with watercolor, I carried on until I'd taken all four objects about as far as I could. I often take the approach of seeing how far I can go with watercolor alone. If I can nearly pull off the illusion of three-dimensionality even before I've brought out the colored pencils, I know the final piece will be just that much better in the end.

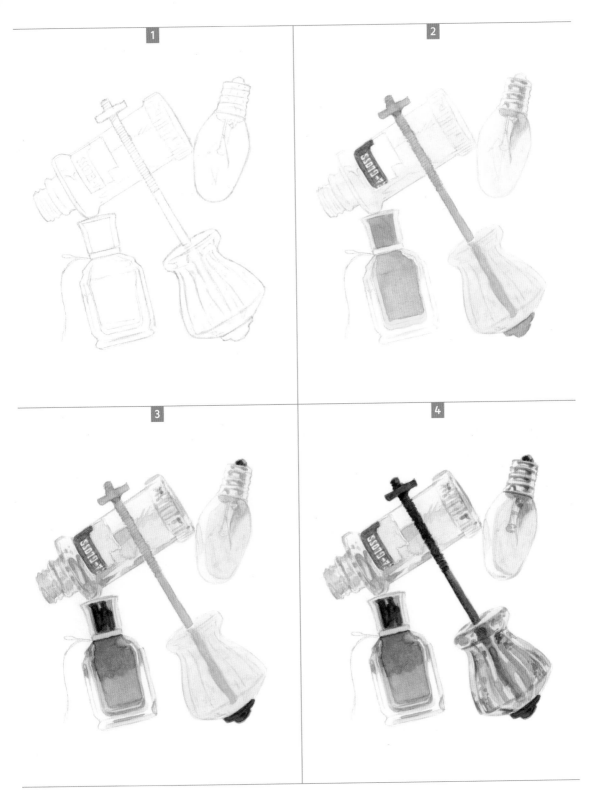

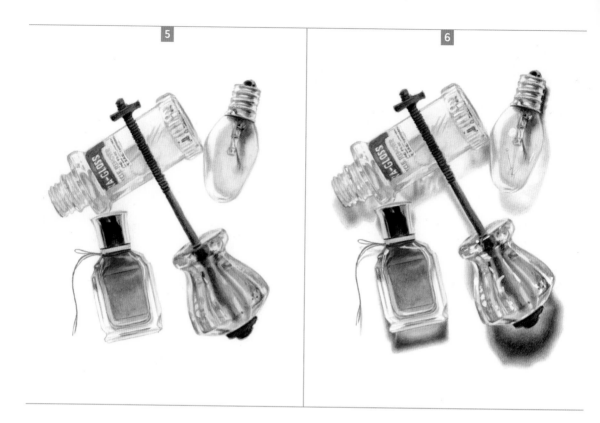

5 But yes, there are indeed things that I find best left to the colored pencils. The bit of purple thread on the perfume bottle, for one. I don't want to even think about how nerve-racking that would be to render with a brush, fine-tipped or not. Throughout the piece, you will find all sorts of areas that benefited from the precision of colored pencils, from the brown of the label to the fine-tuned shading within the lightbulb.

6 Of course, this illustration could never be complete without the drop shadows and white gouache highlights. Those little dabs of white were particularly important for rendering the complexities of the weathered glass knob. It may be tempting to add the highlights earlier in the process, but trust me: they discolor so easily if your hand brushes across them. It really is best to save them for the end.

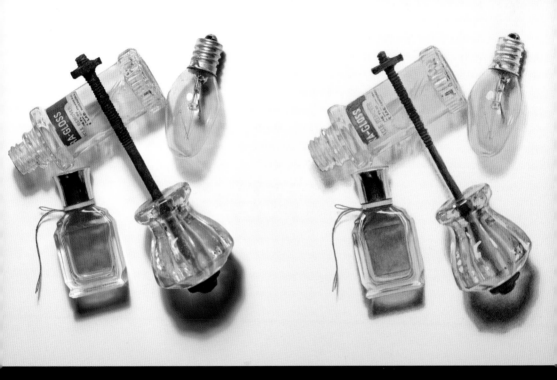

THE FINISHED PIECE From a certain point of view, this lesson's finished piece is the most artistic of everything in the entire book so far. Drawing a single object is fine, but something about capturing a full arrangement of objects connects you to the history of great trompe l'oeil painters and masters of still life. And if you find yourself intrigued by the realism of the lightbulb's metallic base, you'll be pleased to know there's plenty more where that came from. The whole next chapter is devoted to surfaces just like it.

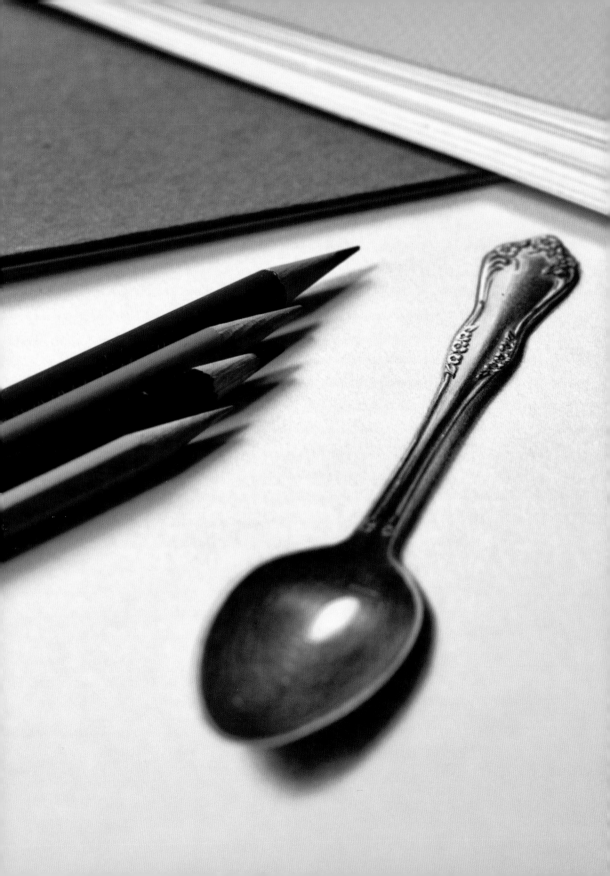

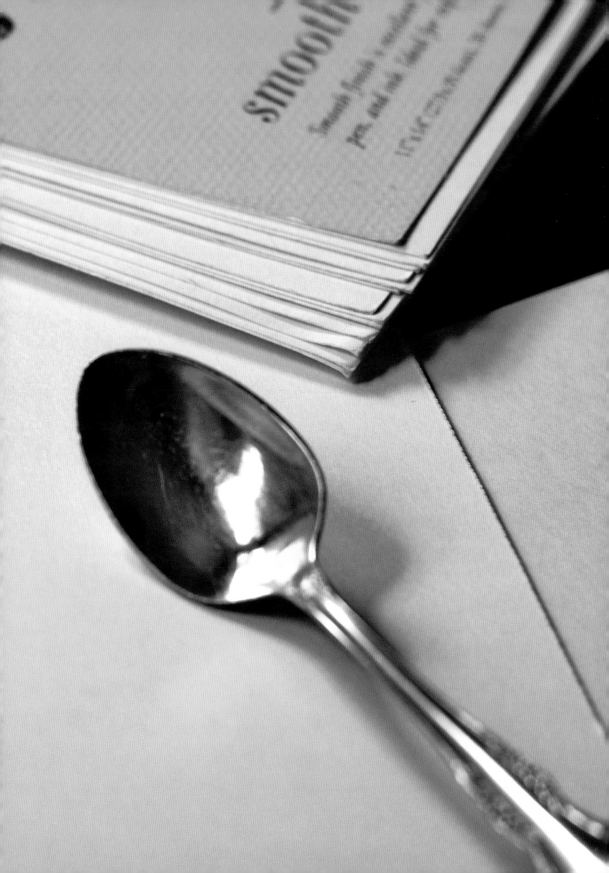

Metallic Surfaces

Stroll though a museum looking at still life paintings and it won't take you long to come across one that includes a shiny metallic object of one kind or another. Painters have long understood the rewards of capturing such surfaces. They provide a certain kind of "eye candy": something about those little glints of light and mirrorlike reflections has dazzled art lovers for centuries. This chapter will help you create illustrations that sparkle and shine with all the authenticity of real polished silver.

Spoon

You don't have to go far to find an ideal subject for a metallic realism challenge. Chances are pretty good you have a few of them sitting nearby in your kitchen drawer. Though I could have just as easily gone with a knife or fork, I liked the subtle curved surfaces presented by this common spoon. If you're nervous about taking on too much detail, opt for silverware with a simpler, more streamlined handle. Me, I saw the intricacies of the floral patterns on this old-fashioned spoon and thought, "Hey, that'll be half the fun."

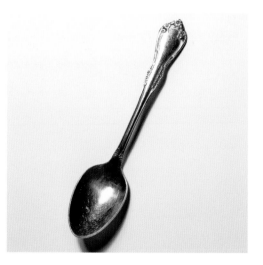

1 Draw the contour of the spoon in pencil. If there are patterns on the handle, go ahead and get those penciled in as well. You can add indications of shadows and highlights if you like, but as you can see from my approach, it's fine to save all that for the later stages.

2 Use watercolor to mix up a light gray base color for the entire spoon. I chose to leave paler areas in the spots where I saw light hitting the spoon, but otherwise I kept things pretty simple. The main thing is to make sure the whole spoon has at least a little color on it.

3 Time to grab a colored pencil and start applying the details. I selected a midtone gray—not too light, not too dark—and began refining the decorative flowers and leaves along the edge of the spoon's handle. Because the light source is on the upper left, my line work is especially pronounced on the right-hand side of each element.

4 Switching to a darker colored pencil, add shading to the area of the spoon's "bowl." I noticed that the surface had a subtle grain to it, so I tried to get that into the illustration by way of hatched line work. If you prefer a smoother look, you may want to add your shading by way of small, circular motions of the pencil, building up the darkness more gradually.

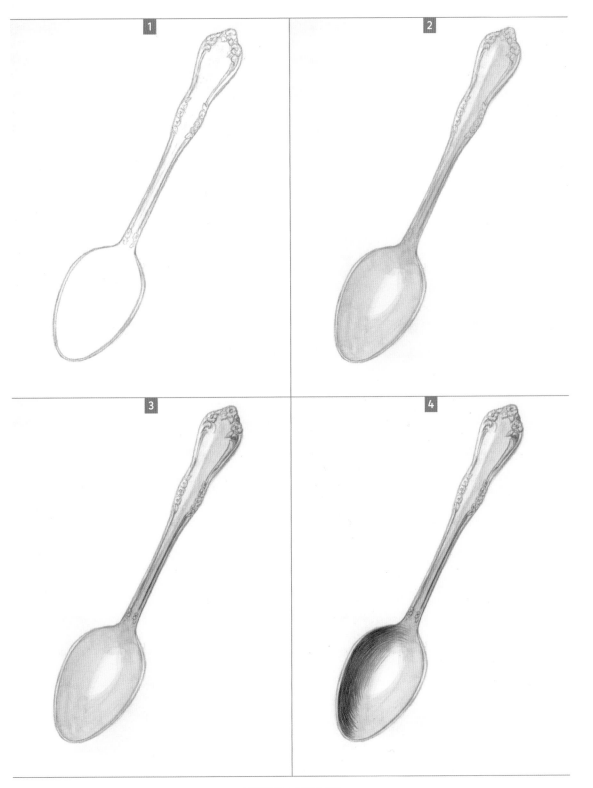

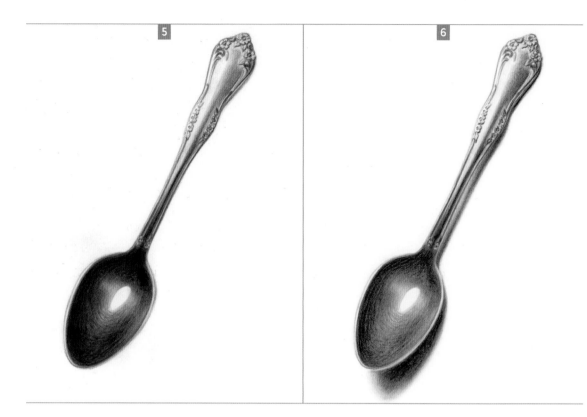

5 At this point, it's a matter of maintaining your patience as you continue darkening the shading throughout the entire area of the spoon. You need to constantly compare your illustration with the target object, seeking any discrepancies between the spoon in your drawing and the spoon in real life. Mostly, it is a matter of darkening areas that aren't yet dark enough, but you may also need to lighten things here and there.

6 Once you're satisfied with your work on the spoon itself, you can move on to the shadow. As always, the key is producing variety in the shadow and keeping it from being a solid black shape. Notice how the tip of the spoon—higher up off the paper— has a shadow that gradually fades from black to gray to the white of the page.

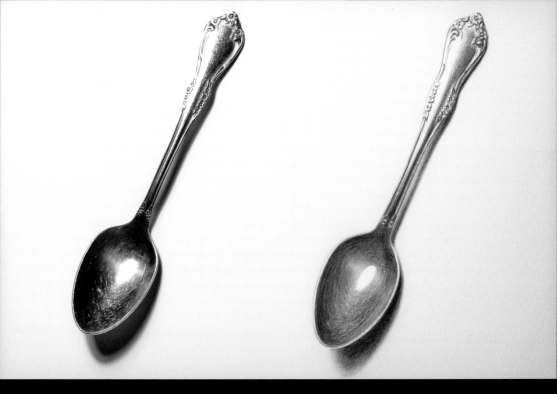

THE FINISHED PIECE A few dabs of white gouache will help complete the illusion. Go lightly, though: a delicate look is what you're going for, and that means tiny bits of white applied in just the right places.

Tin Foil

If high-contrast objects are ideally suited for a realism challenge, then the king of all target objects just might be a humble sheet of tin foil. Crinkle it just a bit and its surface explodes into a dazzling array of whites, blacks, and every shade of gray in between. And though rendering such a surface requires patience, it is in many ways easier to capture than many of the surfaces already covered in previous lessons.

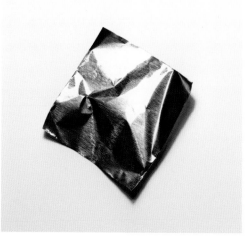

1 In a way, your biggest decision is that of how much you're going to crumple your square of tin foil. The more you scrunch it up, the harder the realism challenge will be. Once you've got your tin foil's surface arranged as you like, pull out your pencil and draw its key elements. As always, measuring with a ruler can help you get the size right.

2 Dab away with an eraser to lighten the lines a bit. Then mix up a moderately pale shade of gray watercolor for your base layer. The crisp edges will come naturally, as that's what watercolor does all on its own. You may need to apply clean water with a brush to achieve a gradual change from gray to the white of the page in certain areas.

3 Continuing with watercolor, begin applying a second layer with a notice-ably darker shade of gray. You may choose to go for some of the finer details as this stage. For the most part, though, it's enough for the look to be fairly impressionistic.

4 Here's how things should look by the end of the watercolor stage. The idea is to capture all the main areas of gray and as many of the smaller areas as you can. When you feel you've achieved the beginnings of a real metallic look, you're ready to pull out the colored pencils.

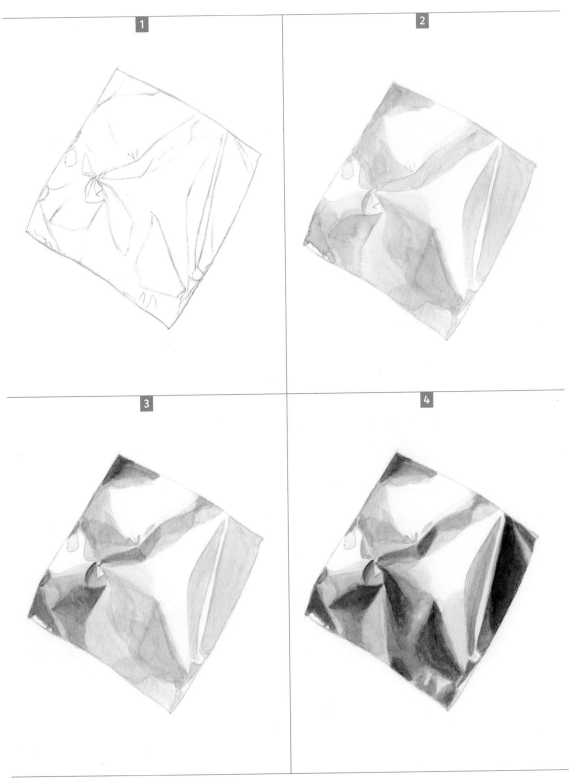

METALLIC SURFACES

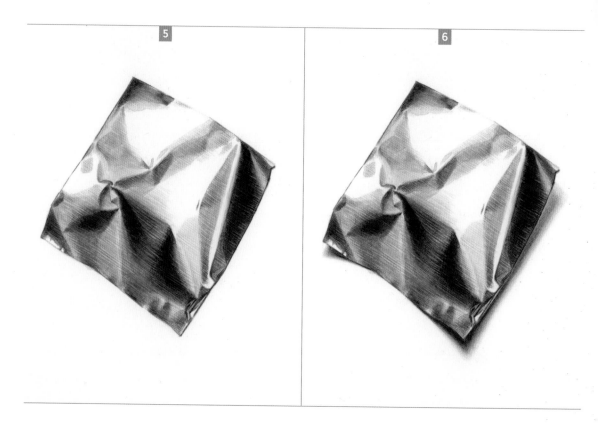

5 Here you see what a difference colored pencils made as I began fine-tuning my illustration from left to right. I noticed a certain "linear grain" to the tin foil and sought to replicate that with parallel strokes of the pencil. You will probably want a combination of light gray, dark gray, and black colored pencils to get the full contrast needed.

6 Once you've worked your way across the entire surface of the tin foil, add the drop shadow. The foil's reflective surface may cause some areas of the shadow to grow lighter. For me, the upper right-hand corner of the shadow became quite pale as light bounced off the underside of the foil and back onto the paper.

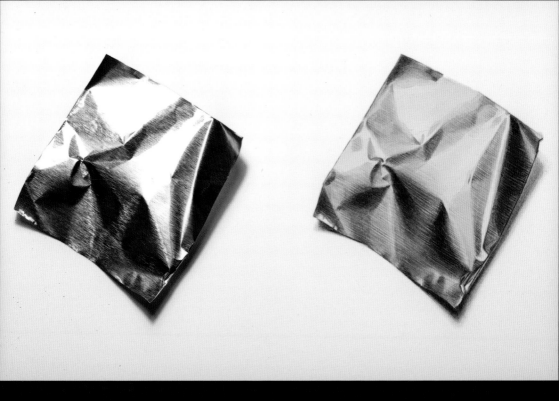

THE FINISHED PIECE A few dabs of white gouache and you're done. I'm always surprised to see how convincing the illusion becomes with these metallic objects. It really is as if the human eye does part of the job for you, convincing itself that this area of the paper shows an actual piece of tin foil.

Rusted Chrome

Just because something is made of metal doesn't mean it shines like a silver tea set. I came across this rusted, beat-up old hub cap and knew it was just what I needed for a metallic realism challenge that would stand apart from the others in this chapter. Oddly enough, you can think of it as a companion piece to the wooden cherub's head on page 62. In that lesson, you saw what aged wood looks like. This time you get to examine a piece of metal that has been around the block a few times.

1 Just so no one thinks I have a super-human ability to draw perfect circles, rest assured I don't. I used a plastic stencil set to get the two concentric circles you see in this initial pencil drawing. I then made a few markings for the places where the hubcap's chrome had cracked and fallen off. Beyond that, I decided to skip penciling in the countless specks of rust. That job could wait. The main thing for now was to focus on the basics.

2 The battered surface of the hubcap created a sprawling area of white highlight quite different from anything seen up until now. Leaving that as the white of the paper, I used watercolor to brush in a simple pale gray everywhere else. The darker areas you see here are a second layer, some of it added before the first layer had dried; in this way, the two areas were able to merge together.

3 Setting the watercolors aside, I switched to colored pencils. The complexity of the hubcap's rusted surface was a daunting task. I chose to ease my way into it, gradually building up darkness in the areas I felt needed it most. Note that it was not just a matter of adding black, but also of adding a nice rusty shade of orange in certain places.

4 Taking my time, I gradually covered the entire hubcap in a good layer of colored pencil. You can see how I moved toward greater detail at this stage, but still allowed a certain sketchiness to prevail. I knew the grainy tone of the colored pencil—its inherent roughness—would work in my favor for this particular piece. Nevertheless, you can see it's not quite there yet. The image remains a bit flat.

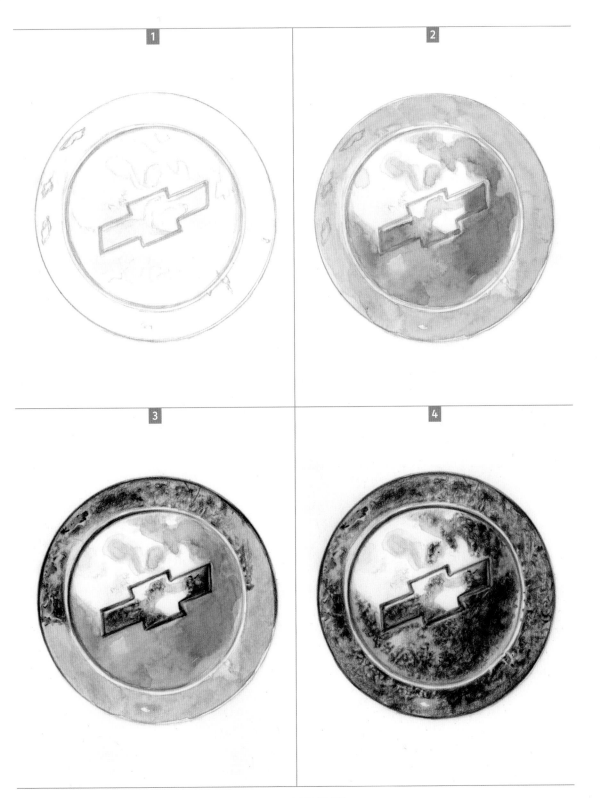

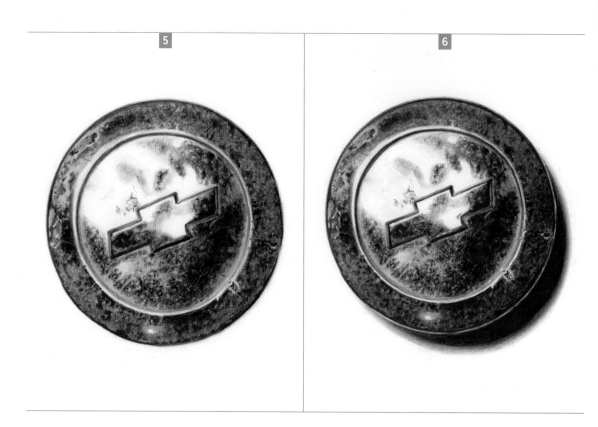

5 To take it to a higher level, I switched back to watercolors, darkening in areas and adding texture throughout. Comparing this picture with the one in step 4, you can see what a difference contrast makes. The deeper the blacks go, the more solid the object seems overall. These effects are not achieved in a few minutes. What you see here was done over a period of hours.

6 To complete the illustration, I added highlights and the drop shadow. As usual with metallic objects, the white gouache highlights make a big difference. But with rusted objects, it's important not to overdo it. The look you're going for isn't really one of pure shininess; it's more of a "compromised shine"—one that's struggling to be seen amid the grit.

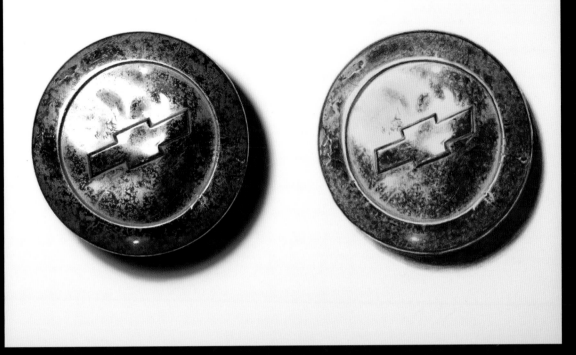

THE FINISHED PIECE Few would say a rusted hunk of metal is prettier than a shining piece of silver, but there is an aspect of visual interest to this finished piece that arguably makes it more intriguing than its counterparts in the other lessons. So keep your eyes open next time you're out for a walk: you just might find an ideal target object lying unnoticed on the side of the road.

Final Polishing

Artists who are capable of making hyperrealistic paintings are justly praised for their extraordinary skills. But when I look at such artwork, I am equally struck by the artist's patience, for I understand just how long it took and how well they resisted the temptation to rush things. At no point in the illustration process is patience more important than in the last stage: the final polish. Compare the images from steps 4 and 5 in this lesson. The differences are quite subtle. But they are absolutely crucial for pulling off the final effect. So when you feel that you are "nearly done" with your illustration, you may well want to put in another hour or two. Darken a tiny bit here. Intensify a sliver of color there. These seemingly imperceptible changes are the difference between a good final result and a great one. They take time and patience. Lots and lots of patience.

Christmas Ornament

Once you learn some of the tricks for illustrating metallic surfaces, you'll begin seeing shiny little target objects everywhere you turn. This past holiday season when I hung this silver bell ornament on the tree, I thought, *Now there's a realism challenge if I ever saw one.* Sure enough, it jingled and jangled its way right into the pages of this book.

1 The relative simplicity of this particular ornament meant that the penciling stage was not too demanding. I was grateful for the loop of red ribbon attached to it, since that gave the drawing a little more visual interest. Whatever metallic object you end up using for this lesson, make sure you place its contour lines and various details as accurately as you can. The time for noticing drawing errors is now, before you start adding color.

2 My approach is always to work top to bottom so as to avoid placing my hand upon artwork just after it's completed. This meant starting with the red ribbon. Knowing that the final color would be quite bold, I mixed up a pretty bright red right from the start.

3 Next, I painted a base layer of light gray watercolor for the ornament. Once that was dry, I added a second layer of darker grays in this same area, and a few spots of black for the star-shaped openings. If you look carefully in the area of the highlight, you can see how I added water to lighten up the gray in that area. I knew I'd eventually want a smoother transition from dark to light, but that could be achieved later with colored pencils.

4 Now I returned to the ribbon and used red colored pencils to add shading and detail. The area of the knot in particular benefited from this added clarity. Observation of the target object showed me that a bit of the ribbon was mirrored in the surface of the ornament, so I made sure to add that to my illustration, using both watercolor and colored pencil to produce the effect.

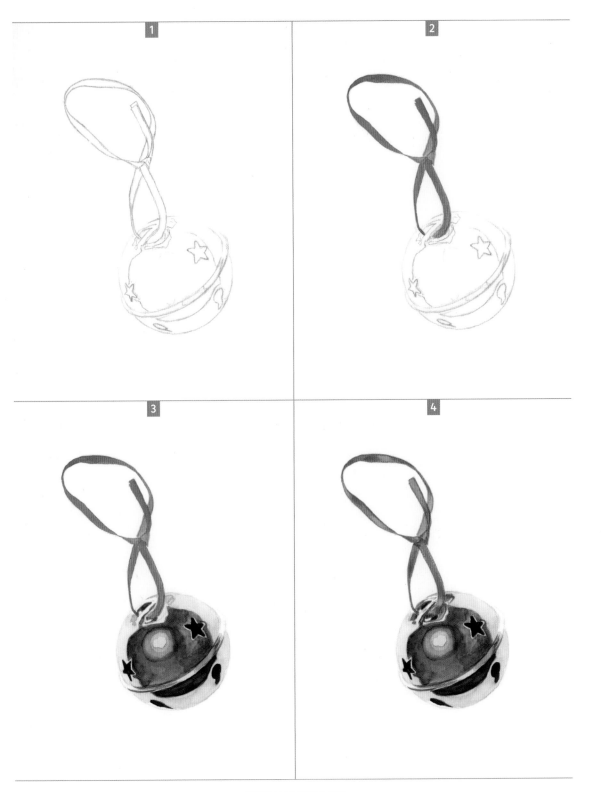

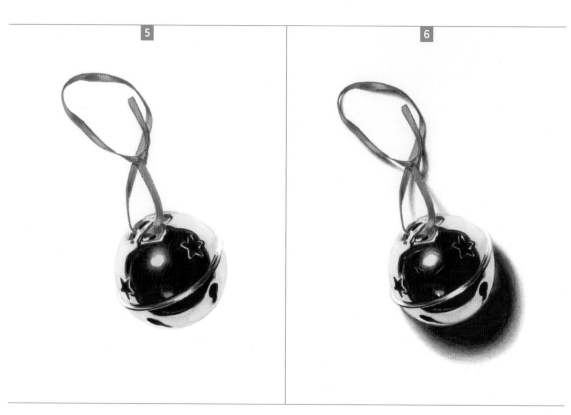

5 I knew the high-contrast area of the ornament would really steal the show if I could capture it, and it did not disappoint. The effect had nearly been there with the watercolor, but I needed the black and dark gray colored pencils to really bring it home. I noticed a certain bluish tint in the area of the big white highlight, so I got that in there with a blue colored pencil.

6 Once the drop shadow was in place, it was time for the highlights. I added them with white gouache as usual, though this time I saw there was also a bit of orange from a secondary light source. So I mixed a bit of that up, combining white gouache with orange watercolor. It's a tiny final touch, but I think it makes a big difference in the finished image.

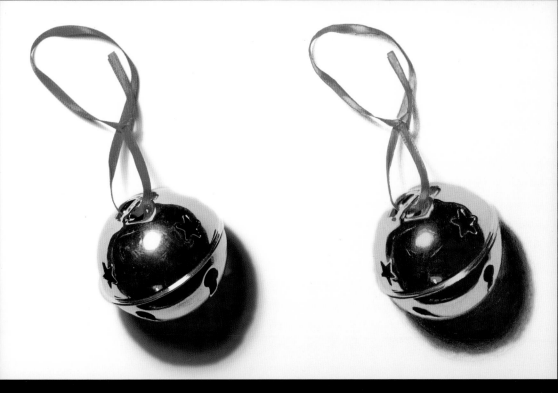

THE FINISHED PIECE You'll be glad to know I didn't deprive the family tree of this ornament for very long. I got it back up there hanging on one of the branches, right where it belonged. But only after I'd finished using it for a nice little realism challenge.

Metallic Arrangement

Starting a new project often requires a trip to the art store. For this piece, I ended up skipping the art store and going instead to the hardware store. There I walked the aisles until I found these four metallic items, each of which I knew would be interesting to illustrate, both in terms of its surface and its shape.

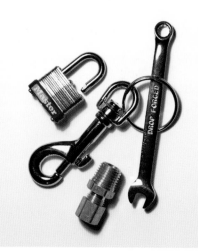

1 Part of your job as an artist begins before you even pick up the pencil. When you're setting up the objects you're going to draw, you establish the composition of your final piece. So take your time. Try moving the various components into different positions until you find the arrangement that looks best to you. Then take the pencil and—after measuring everything with a ruler, if you find that helps—draw the contours and key details for each object.

2 By now, you know my approach for metallic objects: I almost always begin with a base layer of watercolor, so as to have a solid hue to build on. In this instance, one of the objects was a golden color, so that meant a base layer of yellow for it.

3 Next, I used additional applications of paint to take each object as far as I could with watercolor. Note that the highlight areas of the three chrome-colored objects are actually nothing more than the white of the paper showing through. I will later use white gouache to enhance the effect, but it all begins with simply leaving those areas untouched by the brush.

4 I then set the brush aside and began tightening things up, object by object, with black and gray colored pencils. The precision of pencil is especially good for things like lettering. It's interesting at this stage to compare the two objects on the left-hand side of the illustration with the others on the right-hand side. You can certainly see what a big difference the colored pencils have made.

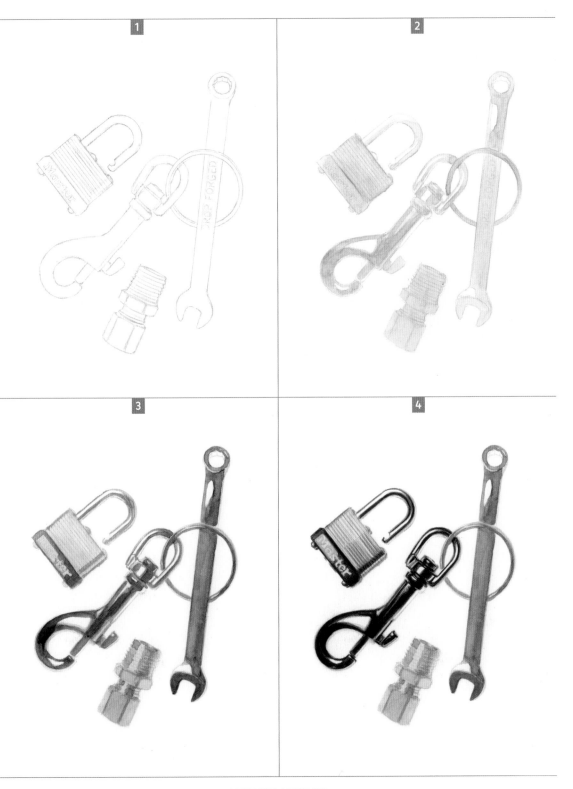

METALLIC SURFACES

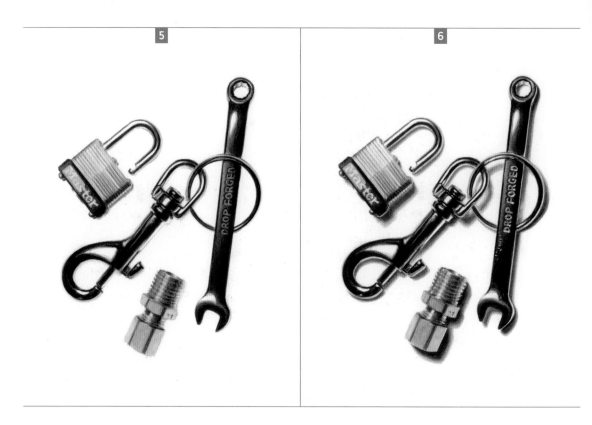

5 I continued with the colored pencils until I'd brought all four of the objects to the level of precision I wanted. The gold-colored piece of hardware required a bit of brown colored pencil, especially in the area of its threads. If you look carefully, you'll spy a hint of blue in the surface of the wrench. A very slight addition of color there, but such small details can make an outsized difference in the realism of the final piece.

6 I generally choose to add drop shadows last, but in the case of these multicomponent illustrations, you may find it just as easy to add them as you go along. As always, the black and gray colored pencils are my tools of choice for the shadows. Notice how a bit of reflected light from the key ring ended up spilling into the shadow of the wrench. It's just another little touch that brings authenticity to the illustration. A careful application of white gouache highlights brought my work to a close.

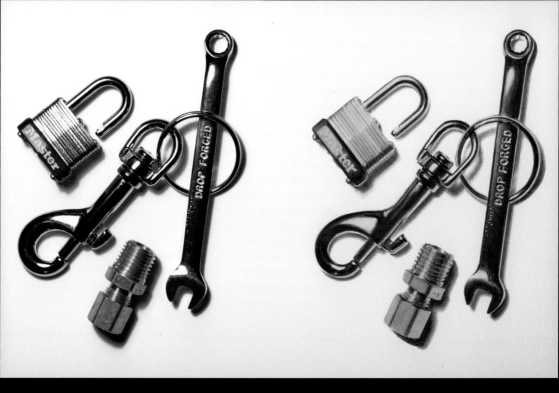

THE FINISHED PIECE I love that all kinds of humble everyday objects can be perfect for a realism challenge still life. You don't need to go to fancy stores and blow a lot of money. You may find, as I did, that it all comes down to a few dollars spent at your local hard-

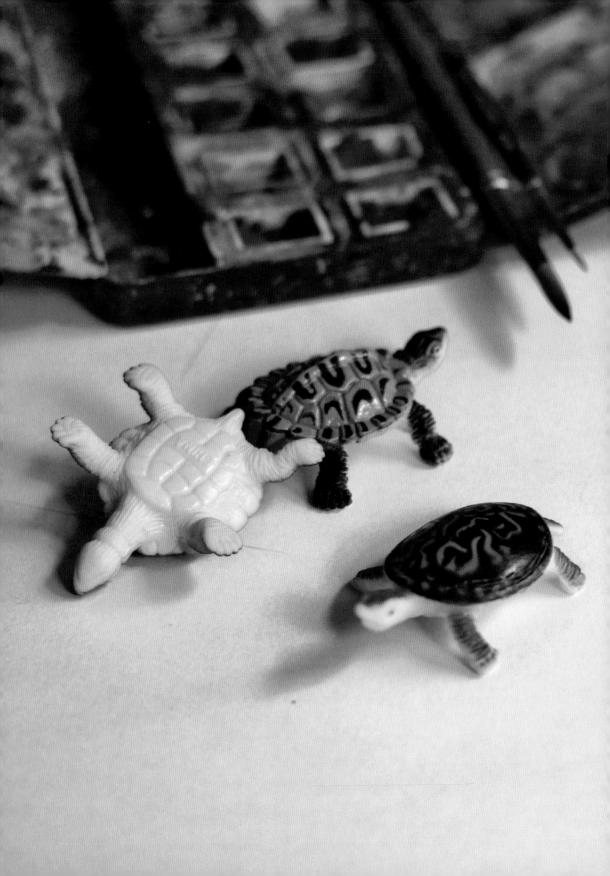

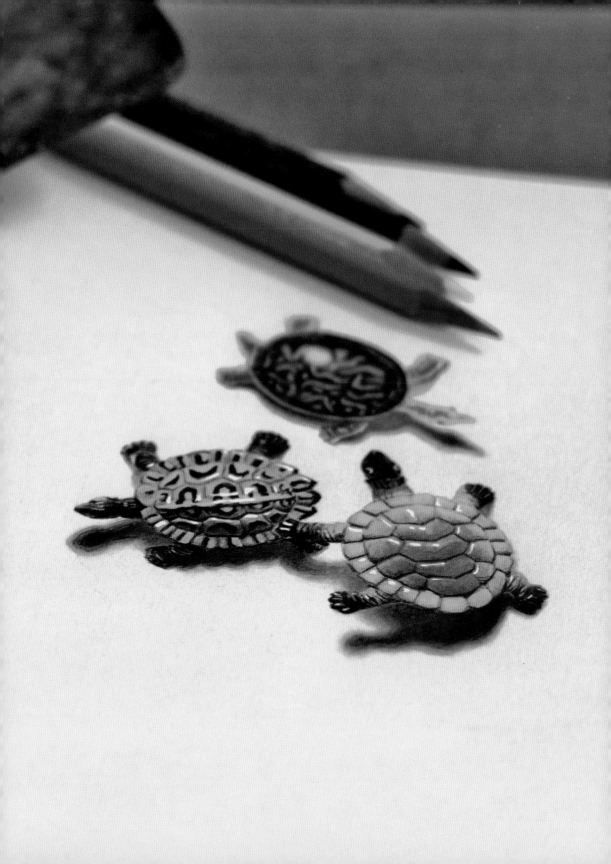

SIX

Manufactured Objects

Not all realism challenges are the same when it comes to degree of difficulty. Manufactured objects often have surfaces that are more complex than those found in nature, which means they may require more time and effort to illustrate. Now that you've completed lessons on tricky materials like glass and metal, you're ready to take on a few factory-made items that are arguably the most difficult realism challenges of all.

Plastic Turtles

We live in an age when a great many things are made from cheap plastic, so I wanted to see if I'd face any unique challenges when attempting to illustrate such items. When I came across these little plastic toy turtles, I knew they had just the sort of semigloss surface I was looking for. They were a little bit shiny, but in a way that was different from items made of glass or metal.

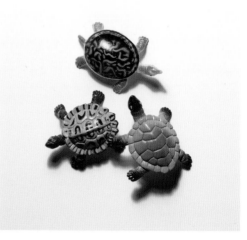

1 The penciling process for my turtles was a bit more involved in comparison with some of the other objects I've covered. So many little details! But that, of course, was part of the reason I chose them. The choice is yours as to how accurate you want to be. An impressionistic approach conveys the general idea of the pattern without getting hung up on accuracy. What you see here, though, is an effort to get every line in just the right place, no matter how much time it required.

2 I began by putting down a fairly pale base layer of watercolor. If you look at the shell of the top turtle, you can see I had the idea of painting all the various squiggles at once. Better to do it now than to try to apply color to them individually later on. As an illustrator, you often have to come up with little strategies like this at the outset. With experience, you begin to find the methods that work best for you and to see in advance what will work and what won't.

3 A second layer of watercolor began to refine things a little. Notice how I added a bit of peach coloring to the shell of the turtle on the bottom right. This is an example of "wet on wet" watercolor. By first dampening the entire area of the shell with clear water from the brush, I was able to paint a stroke or two of peach-tinted color right into the center, where it blurred and blended with the surrounding yellow.

4 Now I set the brushes aside and brought out the colored pencils. Here you see my strategy for the top turtle's shell beginning to pay off. Rather than trying to color all the little squiggles, I blackened in the spaces between them. Imagine if I had started with the reverse: a single dark layer of watercolor for the black of the shell back in step 2. I would have had to mix up some sort of opaque yellowish color for the squiggles and then paint them, one at a time, with a fine-tipped brush. Doable, but much more nerve-racking than coloring the shell with a black colored pencil.

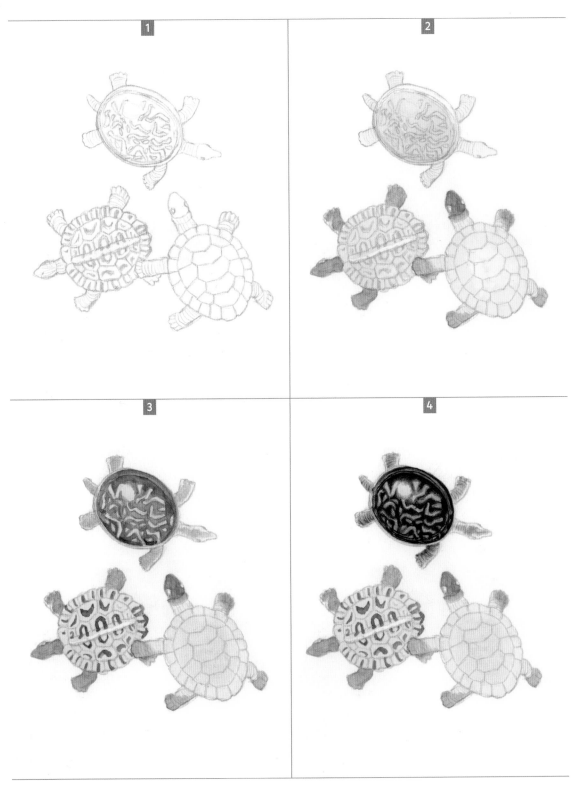

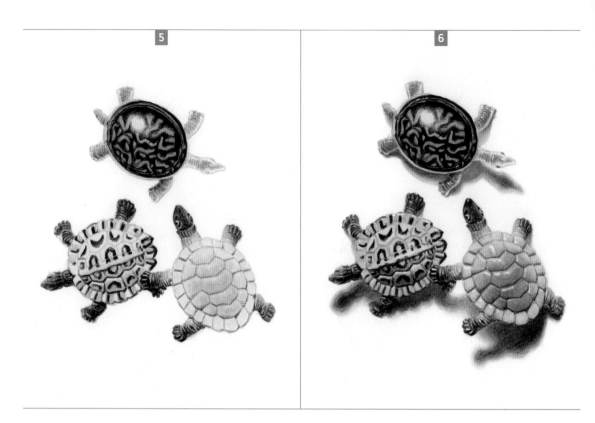

5 And so the process continued with colored pencil from one turtle to the next. One nice thing about combining watercolor with colored pencils is that you can work your way toward the hue you're looking for little by little. The base yellow of the bottom right turtle was a bit too pale back in step 2. Intensifying it with more watercolor would have been tricky: I'd risk messing up that gradual peachy fade I'd achieved in step 3. Happily, I was able to use a yellow colored pencil to add the intensity it needed.

6 Here you see the addition of the usual drop shadows and white gouache highlights. But look closer: you can also see further shading and refinement throughout the piece. This was done during a prolonged polishing phase involving both colored pencils and watercolors. The more care you take observing the target objects, the more little tweaks you will see are needed to make your illustration match them.

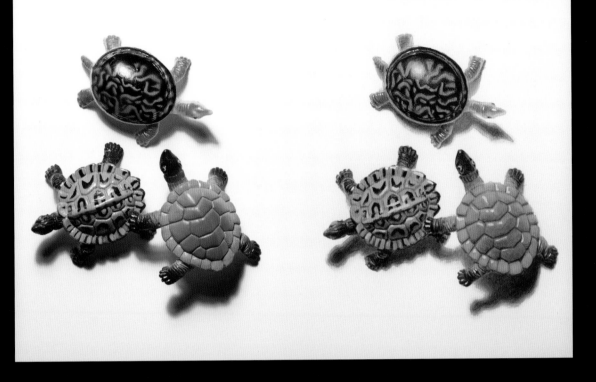

THE FINISHED PIECE There is, of course, endless variety in the sorts of plastic trinkets manufactured today, and each of them has a slightly different surface texture. And while few people would compare them in beauty to an autumn leaf or a red rose, they are not without their attractive qualities. If I can make a nice illustration out of a few cheap toy turtles, I'd say anything's possible!

Envelope with Stamps

I've covered a wide range of items in this book, but one thing I've largely avoided—so far—is an object with printing on it. Still, I thought you and I could venture into this territory for one or two of these lessons. This stamp and its accompanying postal markings present a "printing challenge" that is well within the abilities of the intermediate artist.

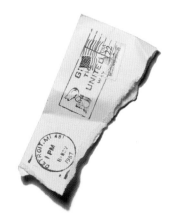

1 You have now come full circle from the first challenge: a torn piece of paper. Happily, this is a pretty easy contour to draw, and depending on what kind of stamped envelope you choose as your target object, penciling the details can be as easy or as challenging as you like. I selected an old envelope with a single stamp, the whole thing slightly yellowed with age. Your job, as always, is to draw the main details as accurately as you can. Take care to re-create not just the markings, but the blank spaces between them.

2 For once, the second step is a piece of cake. Here I mixed up a bit of pale yellow watercolor and brushed it across the entire image, the postage stamp included. Arriving at such a pale shade is a simple matter of mixing in quite a lot of water with yellow paint. Interestingly, this is the one and only time you will use watercolor in this challenge. It's all colored pencils from here on out.

3 The order in which you take on the various details is less important in this lesson than it has been in others. I chose to do the date stamp first, but you could just as easily start with the postage stamp and get similar results in the end. My preference when doing lettering is to use colored pencils. They're so much easier to control than watercolors, and require less effort to maintain a consistent hue from one letter to the next.

4 After that, I moved on to the cancellation frank, taking care to only add printing to the same degree it existed in my target object. That meant leaving the words *way* and *give* partially incomplete. The result is yet another example of an imperfection lending credibility to the illustration. The human eye sees these little flaws and the brain says, *Yes. That's how these things look in real life.*

5 I'll tell you the truth: I saved the postage stamp for last because I knew it would be the most difficult part. A machine can print a microsized picture of the US Capitol building a lot easier the human hand can draw one. Even drawing the nation's flag becomes a bit of a nightmare when reduced this much in scale. All I could do was take a deep breath and dive into the task armed with my colored pencils and as much patience as I could muster. It's helpful when confronting such challenges to take little breaks. Whenever you feel yourself losing patience, just lay down the pencil and take some time off. When you come back, you'll be refreshed and have a renewed commitment to accuracy.

6 When an item is as flat as this one, the shading and drop shadow take on added importance. So take your time and attend to this step as carefully as you can. I noticed that the shadow had a yellow tinge in the area where the inside of the envelope had become visible. And while the paper was not dramatically crumpled, there are a couple of creased lines that could be revealed by way of careful shading. Look at the image from step 5, when I had not yet added such shading, and you'll see what a difference that element makes.

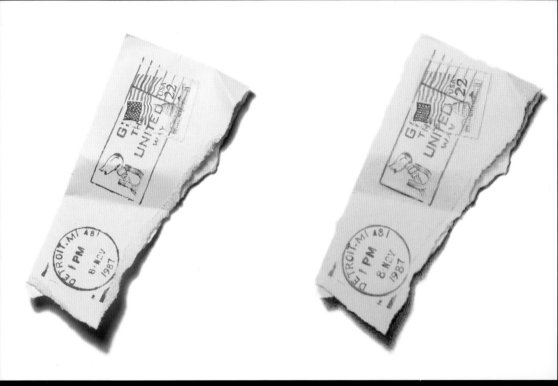

THE FINISHED PIECE Depending on how tricky you found this lesson, you may be wondering why I didn't include more examples of "printed packaging" realism challenges in the book. Then again, once you've tried to re-create a postage stamp by hand at the exact

Salt and Pepper Shakers

As you try re-creating more and more different kinds of objects, you may find yourself looking for opportunities to take on something you've never tried before. For me, that generally means seeking out items with unusual surfaces. I stumbled upon these scuffed up old salt and pepper shakers and knew they'd provide excellent fodder for a realism challenge.

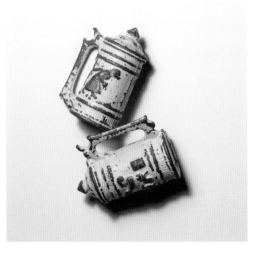

1 The opening stage was pretty straightforward: I used my graphite pencil to accurately draw the two shakers as I saw them. I paid special attention to the areas where the paint had chipped away. If I got any of them in the wrong location it would be tricky to correct the mistake later on. Better to get it right at the beginning, when correcting things is as easy as flipping the pencil around and using the eraser.

2 I then dabbed away at my pencil drawing with an eraser so as to lighten up the lines a bit. Turning to my watercolors, I mixed up a shade of yellow that matched the predominant color of the salt and pepper shakers as closely as I could. Once that was dry, I brushed in just a little more paint to get a little bit of shading into the picture. Nothing too dark, as you can see: just enough to give me something to build on during the later stages.

3 Staying with watercolors, I carefully added dark gray paint to all the "chipped away" areas I'd drawn in step 1. Notice that this gray coloring is not uniform: it's darker in the areas that are turned away from the light source. The decorative figures on the sides of the salt and pepper shakers were slightly embossed. Modulating the darkness of the gray in those areas began the process of conveying this effect.

4 I had fun mixing watercolors into these bright primary hues and applying them where they needed to be in the illustration. Sometimes a target object cuts you some slack: the original color shapes were jagged and irregular, so I didn't have to worry too much about keeping a steady hand.

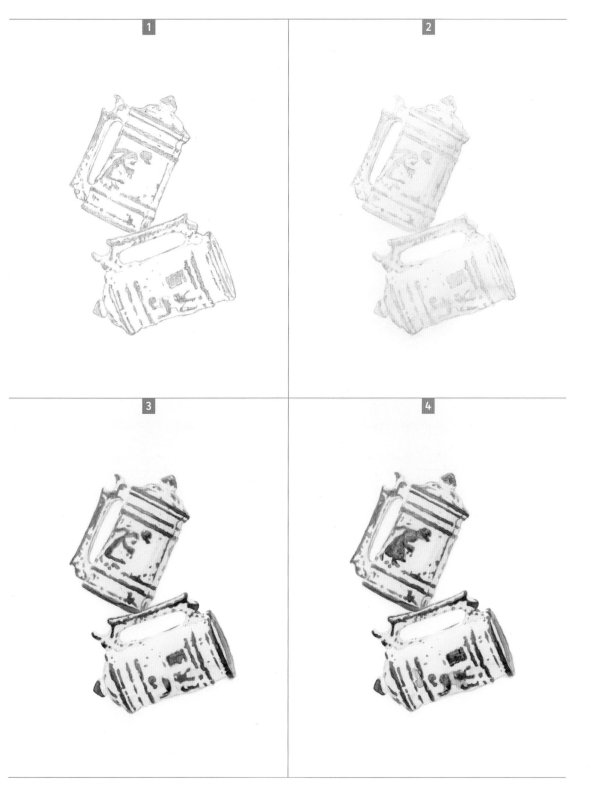

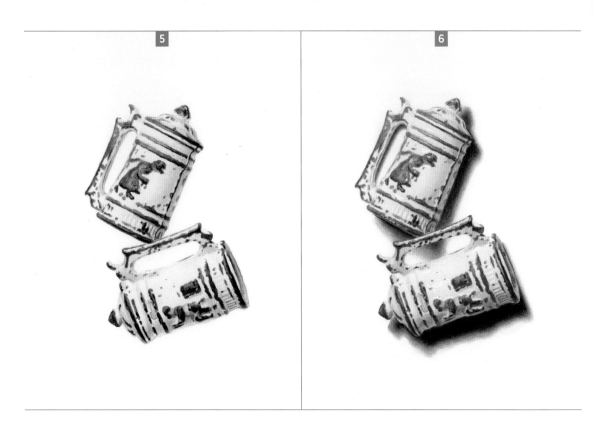

5 Now it's time to bring in the colored pencils and let them do their part. A subtle gradation of color from light to dark can be hard to control in watercolor. Not so with colored pencils. I was able to gradually build up a darker area of color in all the areas of the salt and pepper shakers that were turned away from the light source. These gradual changes in darkness are the key to making objects appear fully rounded.

6 Finally, I added the drop shadows and the white gouache highlights. These objects had a sort of matte finish, so I had to be careful not to make the gouache too bold, which is the mark of a slick or shiny surface. It's interesting that one of the objects has a lighter drop shadow than the other. I think what's happening is that the lower one is reflecting light, partially illuminating the shadow of the other.

THE FINISHED PIECE It must be said that not all objects are created equal when it comes to realism challenges. If the item's surface is too plain or uniform in color, your finished illustration will be correspondingly dull. As you do more of these projects, you'll develop an eye for what objects work best, and believe me, you'll know them when you see them.

Choosing Your Target Object

With a realism challenge, you make your first big artistic move long before your pencil even touches the paper. When you decide what object you are going to illustrate, you make what is arguably the most important aesthetic decision in the whole process. And while it is true that pretty much anything can be given the realism challenge treatment, real artists will not be satisfied with "pretty much anything" as a target object. My instincts often lead me to antique shops, where seemingly every item has a story behind it and a correspondingly rich patina of age to its surface. You may be drawn to brand-new items and their glossy, unblemished surfaces. The important thing is that you select your object with care and not just grab whatever happens to be lying around. Whether it be an item that has special meaning to you or one that you simply find pleasing to look at, select an object that is really worthy of the time you're going to devote to rendering it.

Chocolate Bars

Most of the lessons in this book are focused on a single material of some kind: glass, metal, wood, and so on. As you advance in your skills, you may want to take on a realism challenge that includes more than one type of surface. I wanted to try illustrating shiny cellophane packaging, but then I thought, *What if I tear it open?* That way I could illustrate both the packaging and its contents. So it was that I settled on the image of the candy bars you see here.

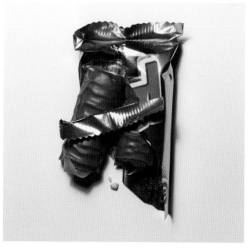

1 Not wanting to overload the lesson with too many problems, I decided to tear the packaging in such a way that most of the lettering was removed. The pencil stage is always the time to check and double-check the item for accuracy. I actually took a moment to count the number of "zigzags" in the end pieces of the cellophane packaging. If you're going to do something, why not do it right?

2 The packaging I needed to replicate was a warm, golden color. I decided to begin with a layer of pale yellow watercolor, with the goal of building up the necessary browns and blacks in subsequent stages. As for the chocolate bars, I laid down a fairly dark brown watercolor base, planning to go darker (with colored pencils) and lighter (with white gouache) later on.

3 Here you see me going in with further layers of watercolor. The cellophane packaging provided plenty of high-contrast areas that I knew were crucial for pulling off the shiny effect. Using my fine-tipped brush, I carefully added the different shades of brown watercolor needed in each location, constantly checking the target object for guidance. For the top of the red *T*, it was enough to get a solid shade of red in place. To achieve this level of opacity, I mixed in only as much water as needed, to make the color move across the page.

4 In this manner, I continued with the watercolors, refining each area of the illustration from top to bottom. The chocolate bars presented a challenge—insofar as the gradient shifts in color were quite subtle. I knew I'd have better luck approximating those subtleties using colored pencil. Still, I took it as far as I could in watercolor, knowing it would look that much better when I switched from one tool to the other.

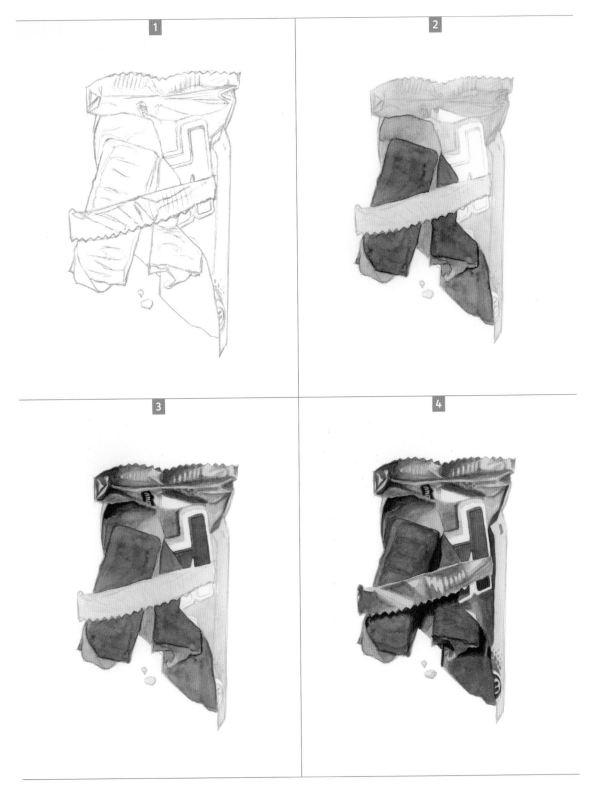

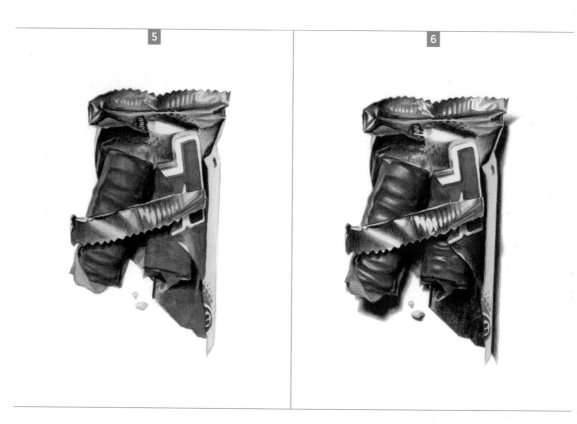

5 Out came the colored pencils, and I was able to tighten things up throughout the entire illustration. Additions of black in the shaded areas were particularly helpful for making the picture look more three-dimensional. As planned, a dark brown pencil allowed me to give substantially more form and solidity to the chocolate bars. Sometimes your shading process lets you push something back a bit—the silver interior of the cellophane, for example—so that other elements can "pop" a little more.

6 The addition of white gouache made a particularly big difference with this challenge. Cellophane naturally produces loads of white highlights, and even the chocolate had a bit of a pale white shimmer to it. You've got to be careful not to overdo it, though. Add the white gouache highlights only where you see them in the target object. Your goal is always to capture the real world effects of light on surfaces: nothing more, nothing less.

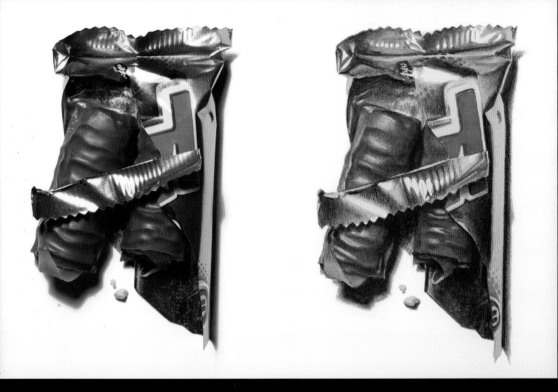

THE FINISHED PIECE Part of what makes this challenge interesting is the fact that it presents two contrasting surface textures. Your eye enjoys comparing the cellophane and the chocolate to see how they differ. Of course, you don't have to stop at just two different items in one realism challenge. Up next is the final realism challenge, and it will bring together all the various skills you've learned so far.

The Ultimate Realism Challenge

It's time to dig deep and go for the "ultimate realism challenge": an assortment of objects combining glass, metal, wood, and other surfaces to really put your skills to the test. It's more than just a final exam, though. The end product of this lesson is arguably closer to something you'd see in a museum than anything else in the book. It's a full-blown still life—a selection of various objects arranged to please the eye.

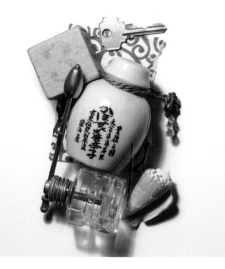

1 Of course, your ultimate realism challenge will be different from mine, and you can adjust the degree of difficulty at the outset. The more ornate and highly detailed objects you choose, the more time consuming the whole piece will be. The only prerequisite I'd suggest is this: try to include at least three or four objects. You're creating a composition here, and that's hard to do if all you're working with are two items. This step 1 will likely take more time than any of the others. The pencil drawing you see here took me well over an hour to complete.

2 As is so often the case, the process begins with a base layer of watercolor. Among my objects, the "elephant in the room" was the calligraphy on the Japanese spice jar. I knew I'd have to deal with it at some point, so why not tackle it early on and get it out of the way? I decided to do the wooden block in two steps—wood surface first, printing second. I always prefer to fill an area completely with a single color if I can get away with it.

3 Next, I moved on to a secondary layer of watercolor, this time going for more of the details. Things began to come into focus here, but I couldn't be a perfectionist at this stage. It's all about laying the groundwork for the more nitpicky stuff yet to come. Certain areas got more of my attention at this stage than others: the pattern on the shell and the rope on the spice jar, for example. These bits lent themselves to watercolor precision, so I went in and took them as far as I could go. The grain of the wooden block, by contrast, was best left to colored pencils.

4 Switching to colored pencils, I began refining the objects one by one. The area of the key is an interesting example of watercolors and colored pencils working in concert. If you look back at step 3, you'll see that the watercolor base was little more than a very pale shade of yellow with a stroke or two of muddy brown on top. Adding the drop shadows was, of course, important, but equally so was the addition of gray colored pencil across the surface. The addition of color and texture here conveys the metallic surface in a way the watercolor wouldn't have on its own.

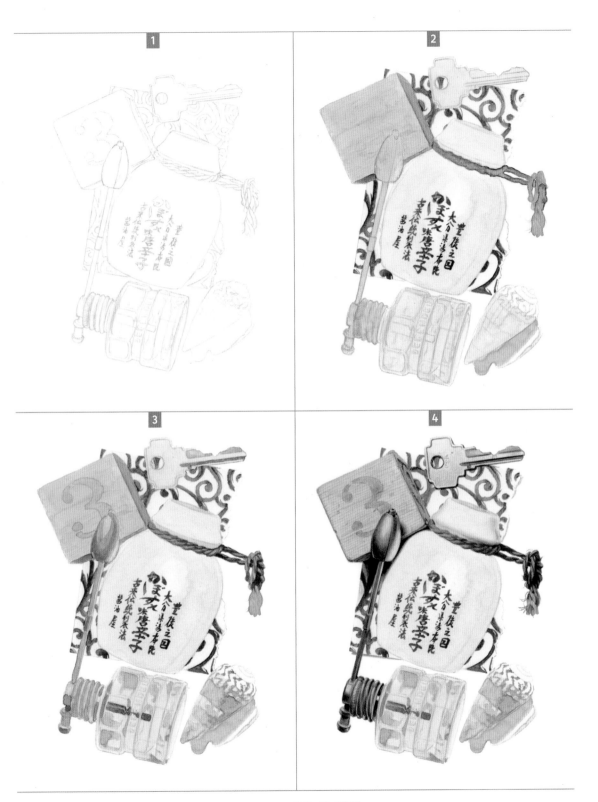

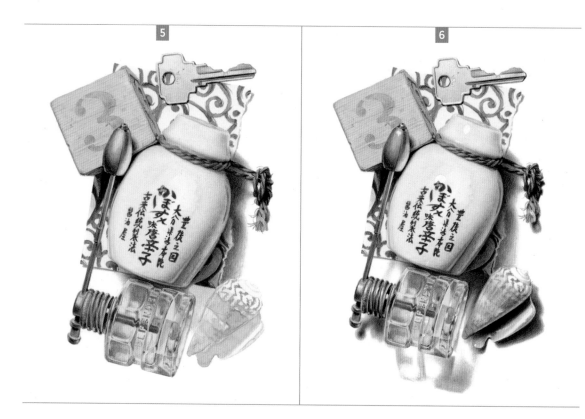

5 I continued the process of refining each item, switching back and forth between watercolors and colored pencils as I went. I decided with this one to add the drop shadows in these earlier stages rather than wait until the end. The area of the glass bottle offered a variety of challenges. The thickness of the glass made it translucent rather than fully transparent, unlike the glass items in chapter four. There was also a tinge of mint green to it that I found pleasing to the eye, if tricky to match. As if these were not sufficient artistic hurdles, the bottle also had embossed lettering. For me, this realism challenge earned its "ultimate" modifier, that's for sure.

6 At last, I came to the area of the seashell, an object that definitely benefited from the natural graininess of colored pencil. It was interesting to see how the white gouache highlights needed to be applied in different ways depending on the object in question. The Japanese spice jar required just a few brush strokes, judiciously placed. The glass bottle needed a good dozen or so of them, some as tiny as a single dot. After many hours at the task, I confess it was a pleasure to lay down the brush and declare my work complete

THE FINISHED PIECE As someone who undertook thirty realism challenges for the creation of this book, I can tell you I completely understand if you don't have the time or energy to follow every single one of these lessons. But if you have to pick and choose, I'd urge you to consider making at least one of your projects an "ultimate" challenge. Nothing compares to the feeling of accomplishment you have when you finish an ambitious piece like this. It forces you to go beyond practicing your technique to actually following in the footsteps of great artists.

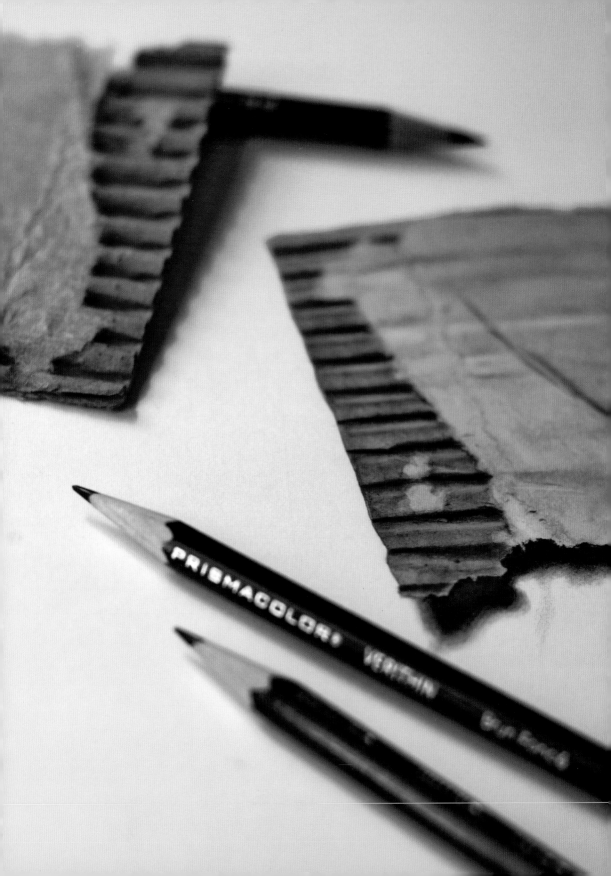

Conclusion

Maybe the best thing that can be said about the realism challenge is that it forces you to open your eyes. When you've got a busy schedule—and these days most of us do—it's easy to speed through the day without looking at anything. Yes, of course, you see everything around you, but how often do you stop to really look closely at something? To examine every tiny little detail of it?

Even better, the realism challenge often invites you to look at things that wouldn't normally warrant your attention. Yes, we all know that a sunset is lovely. Most of us will notice the beauty of a cardinal if it lands on a nearby branch. But how many people are going to stop to admire a plastic bottle filled with water? Or a sheet of crumpled tin foil?

We know on an intellectual level that beauty is all around us. But a realism challenge forces you to put this concept into action. In doing a faithful copy of even the most ugly looking piece of junk, you gradually come to see the beauty in it. You will notice how the light falls upon it. You will see all the little details that make it unique. Even if it is an object you've seen a thousand times before, you will see it as if for the first time. If you're lucky, something of this ability to see—to *really* see—will stay with you as you go about your daily routines.

And if someone passing by gives you a funny look as you stand there gazing deeply into a scrap of torn-up cardboard, well . . . let them give you that funny look. You haven't lost your mind. You've simply found your next realism challenge.

Index